Margo Veillon
Egyptian Festivals

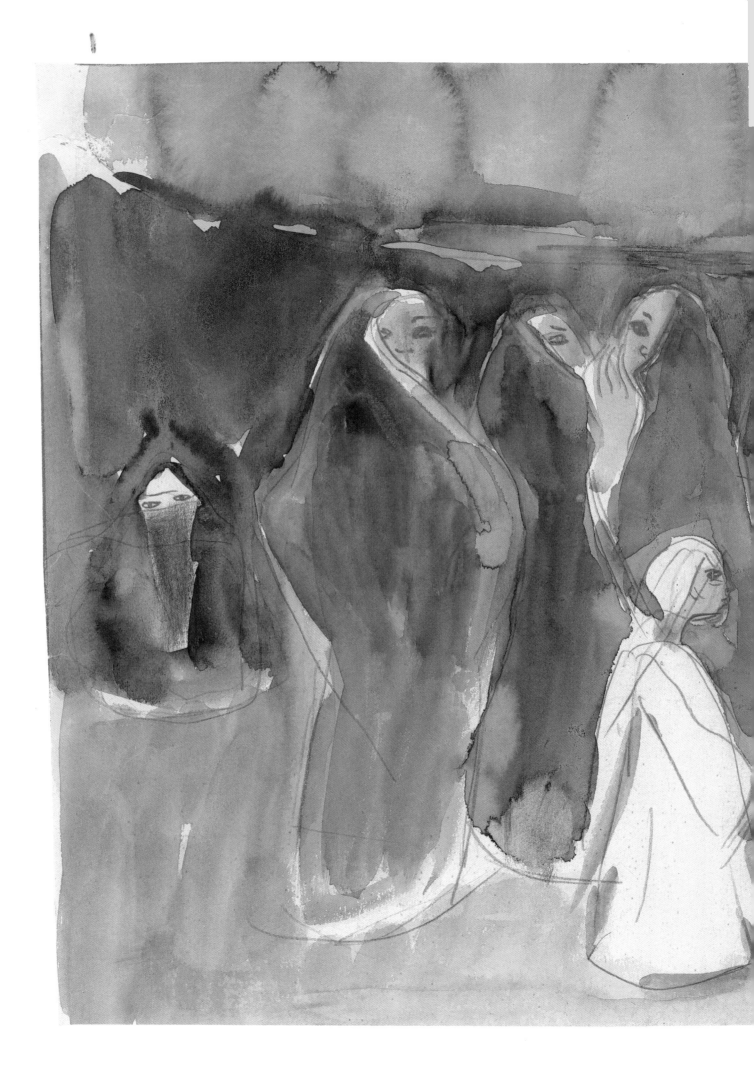

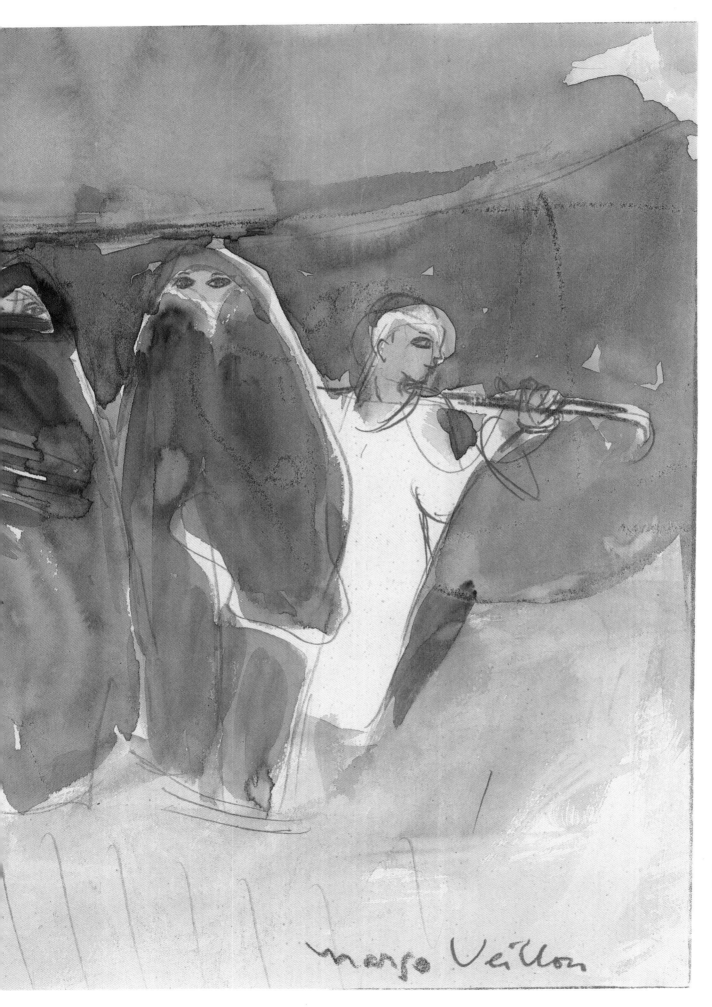

*Women outside
the festival tent,*
watercolor, 22x31

margo Veillon

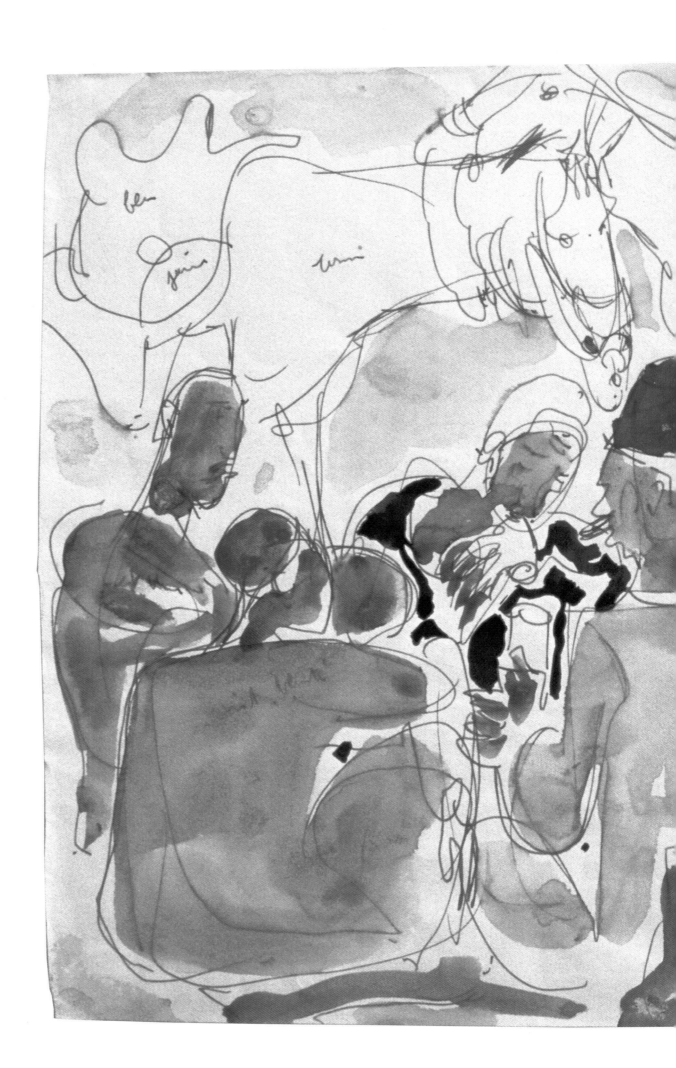

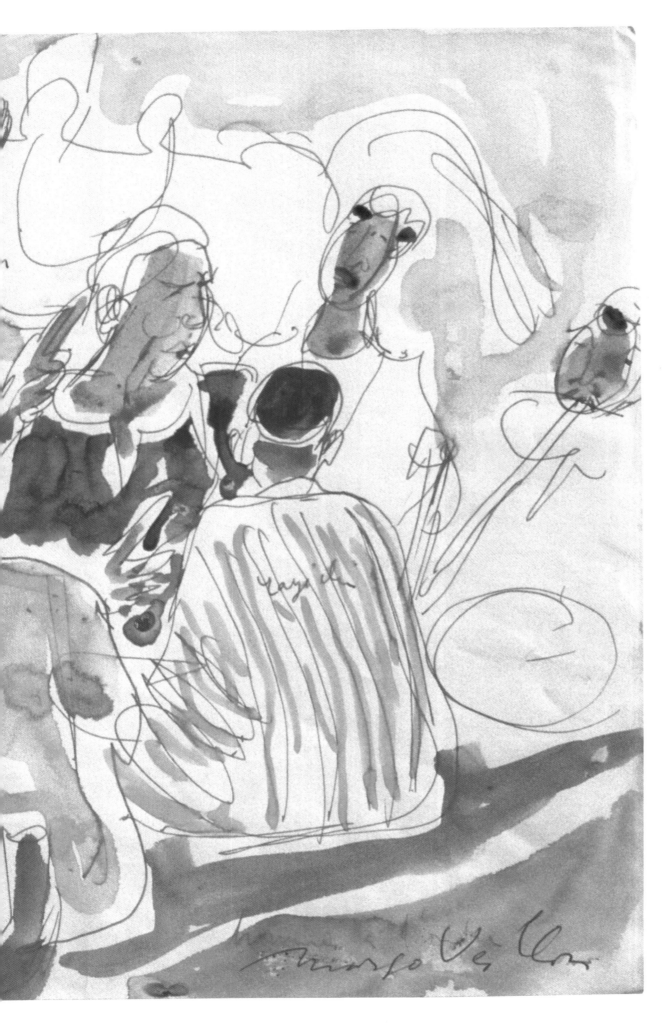

Riders and grooms,
watercolor and ink,
23x31

Dar el Kutub No. 16703/01
ISBN 977 424 694 2

Designed by AUC Press Design Center/Andrea El-Akshar
Printed in Egypt

Opposite page: Untitled, mixed media, 17x35

Margo Veillon
Egyptian Festivals

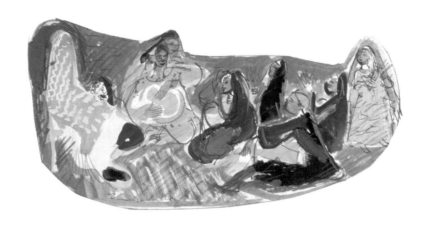

Edited by Bruno Ronfard

With an essay by John Rodenbeck

The American University in Cairo Press
Cairo New York

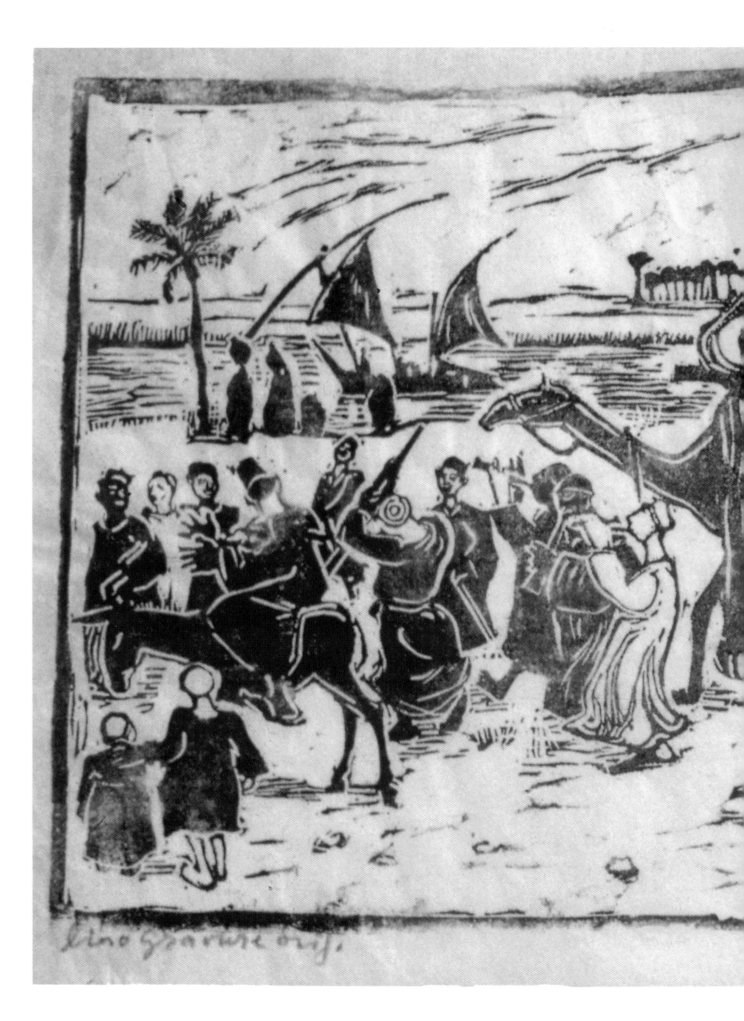

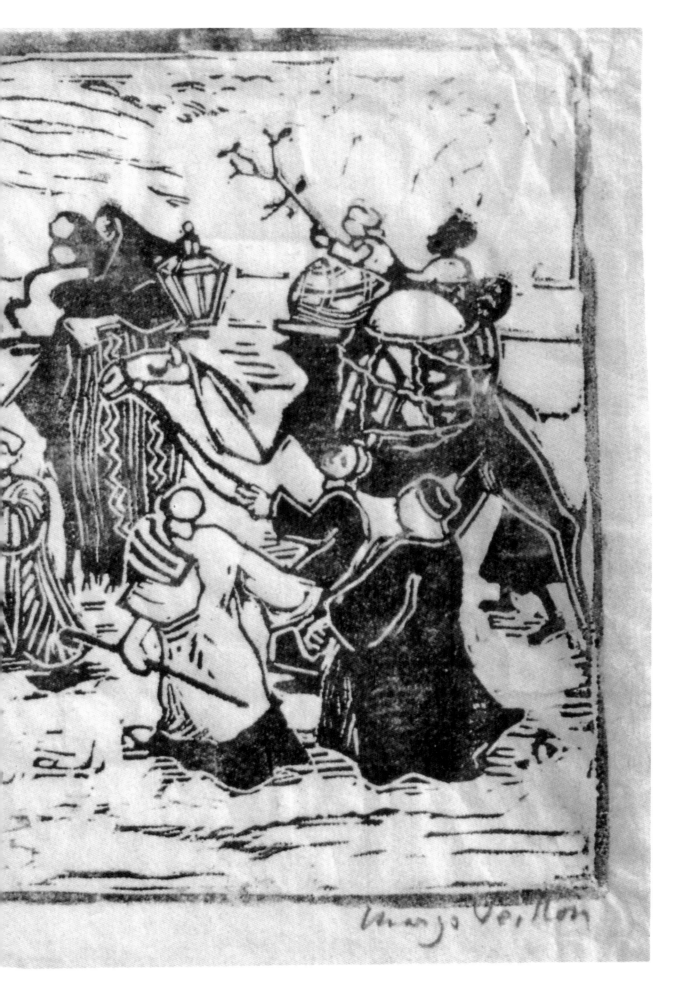

*Wedding
procession,*
lino cut,
27x64

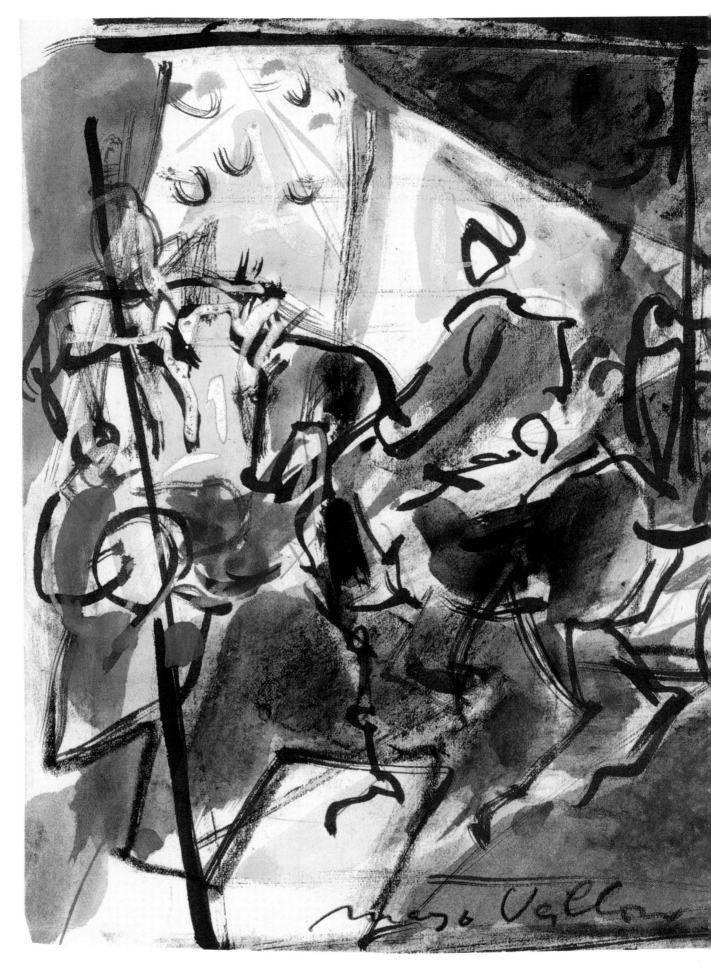

Dancing horses under festival tent, mixed media, 21x32

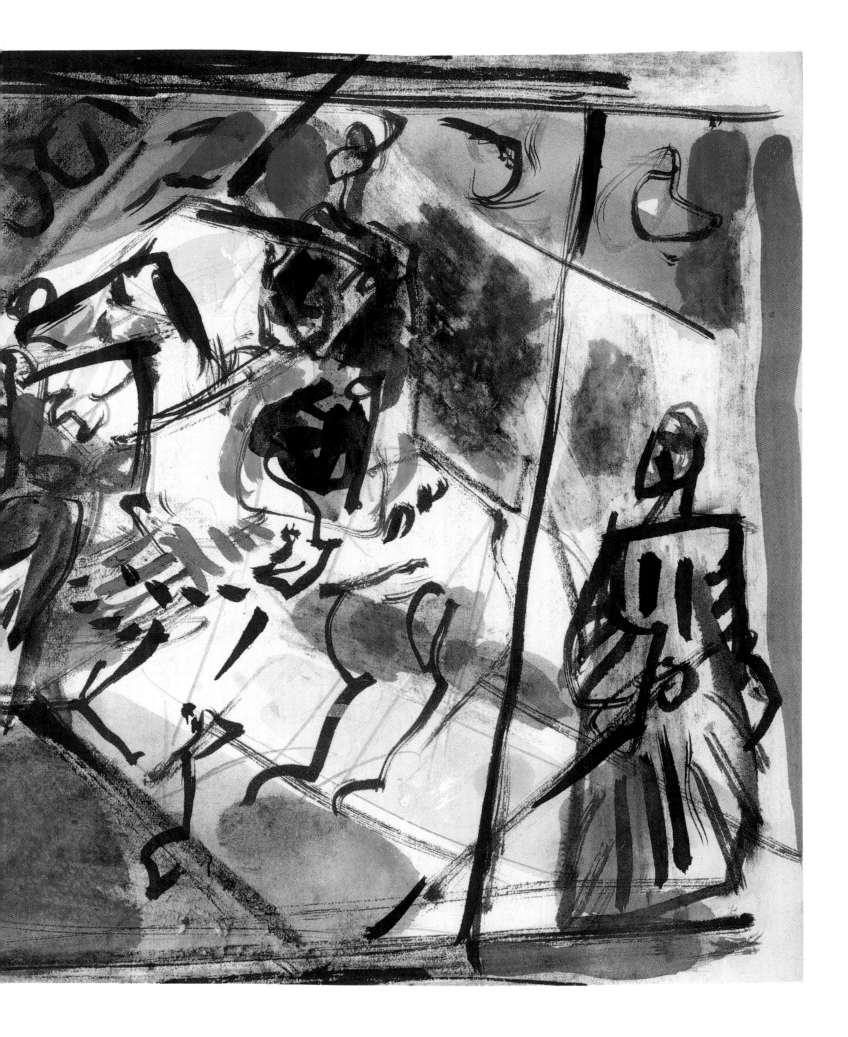

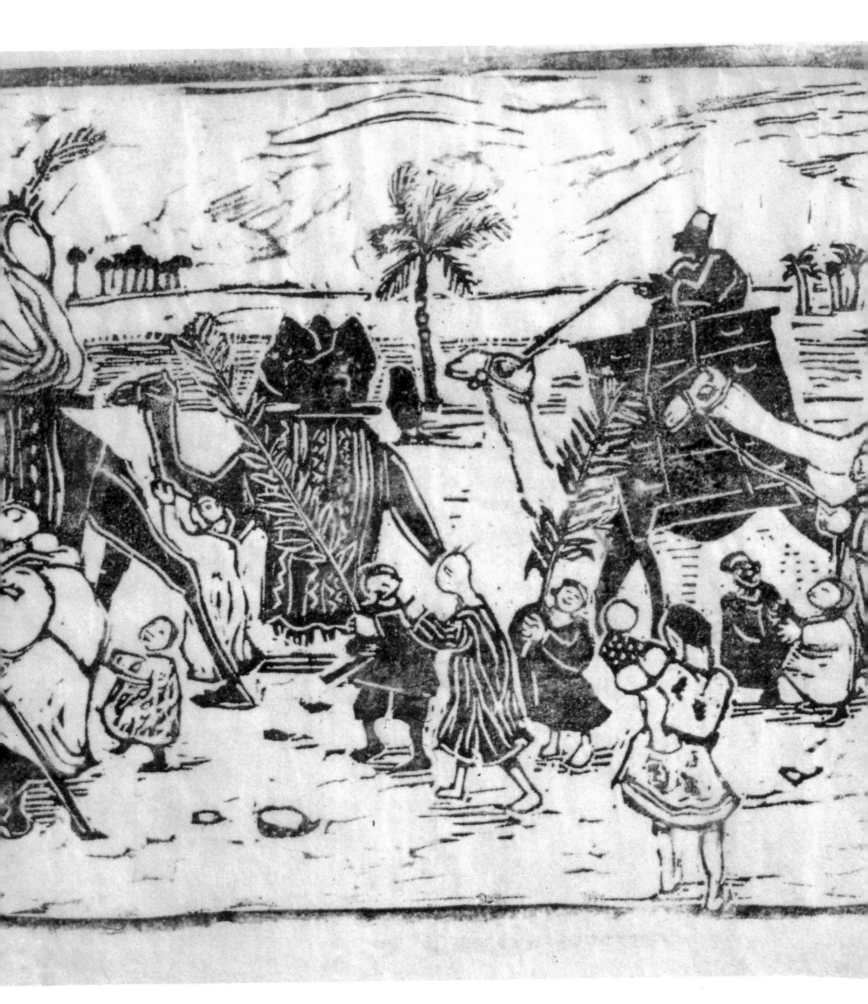

Contents

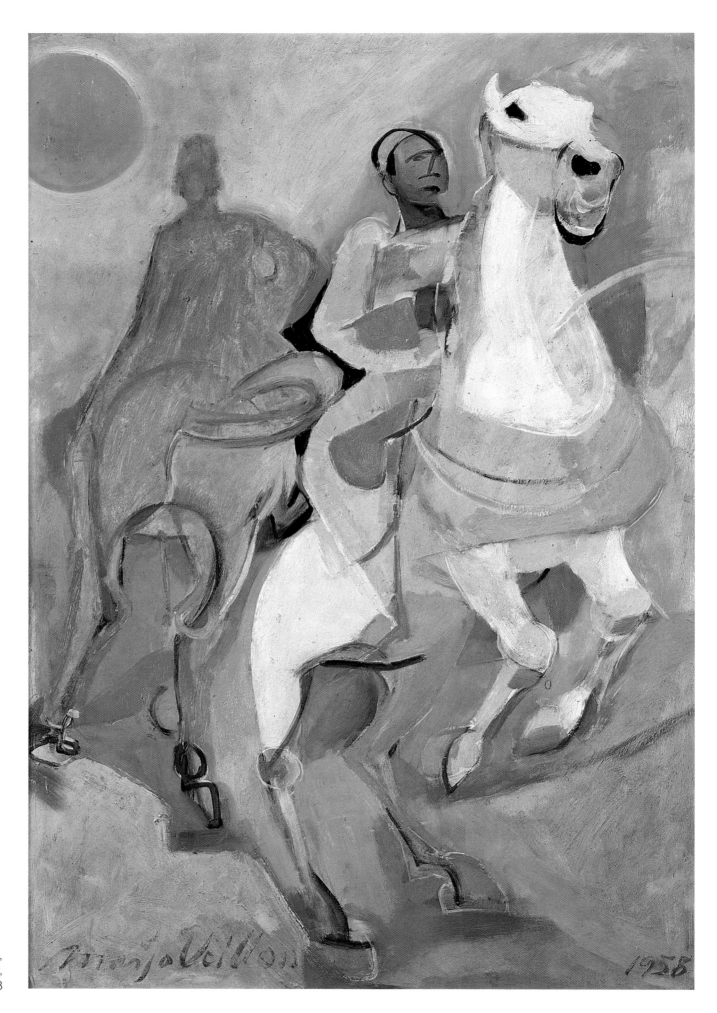

Untitled,
oil on paper,
24x35, 1958

What is essential? This is where the expression of each painter becomes evident. What is the source of inspiration? One counts on observation, another draws on the intellect, a third needs the influence of an artistic movement. With me, it's observation, searching for the essential. In a movement or a characteristic, there is always a captured moment that one can develop infinitely: it is a source. Of what is seen. I see. My eyes drink and then fix and develop. It's an operation to rapidly fix a moving action, an action more or less repetitive. The experience of the harvests, of the horses dancing at weddings, of the building workers . . . all happens in an instant, and the trained eye encompasses all these scenes and the compositions for future paintings. There is a great difference between a finished canvas and scattered sketches. But this first visionary trick is as valuable as the regular work, day after day, on a canvas.

Margo Veillon

Cairo, December 1998

(written on the occasion of the exhibition "Capturing the Essential" at the Cairo–Berlin Gallery)

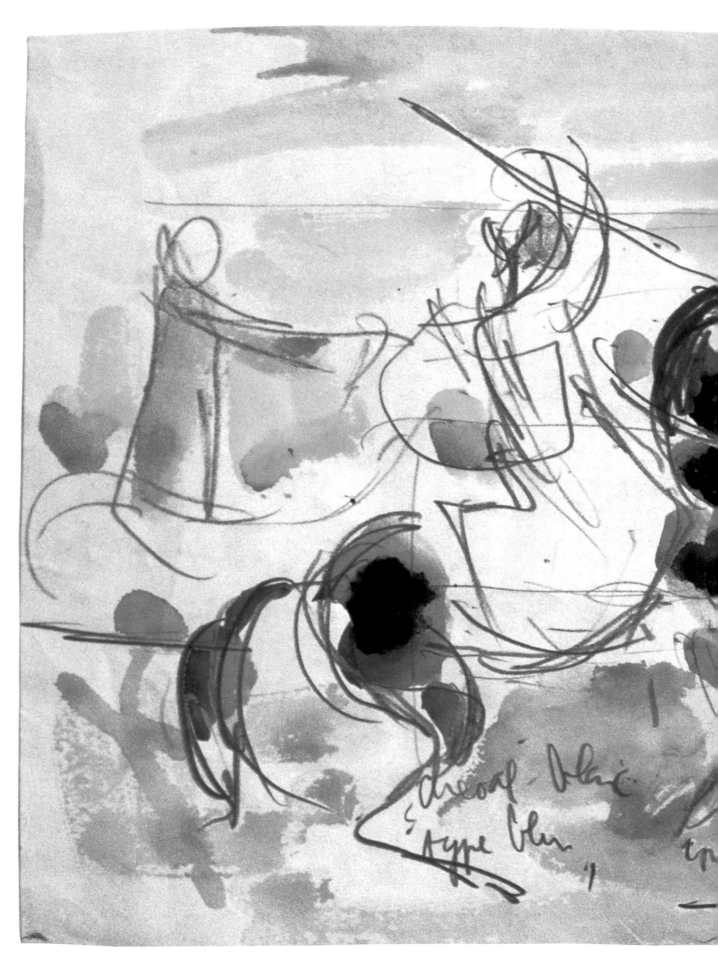

Two horses at sunset, pencil and watercolor, 27x41, 1937

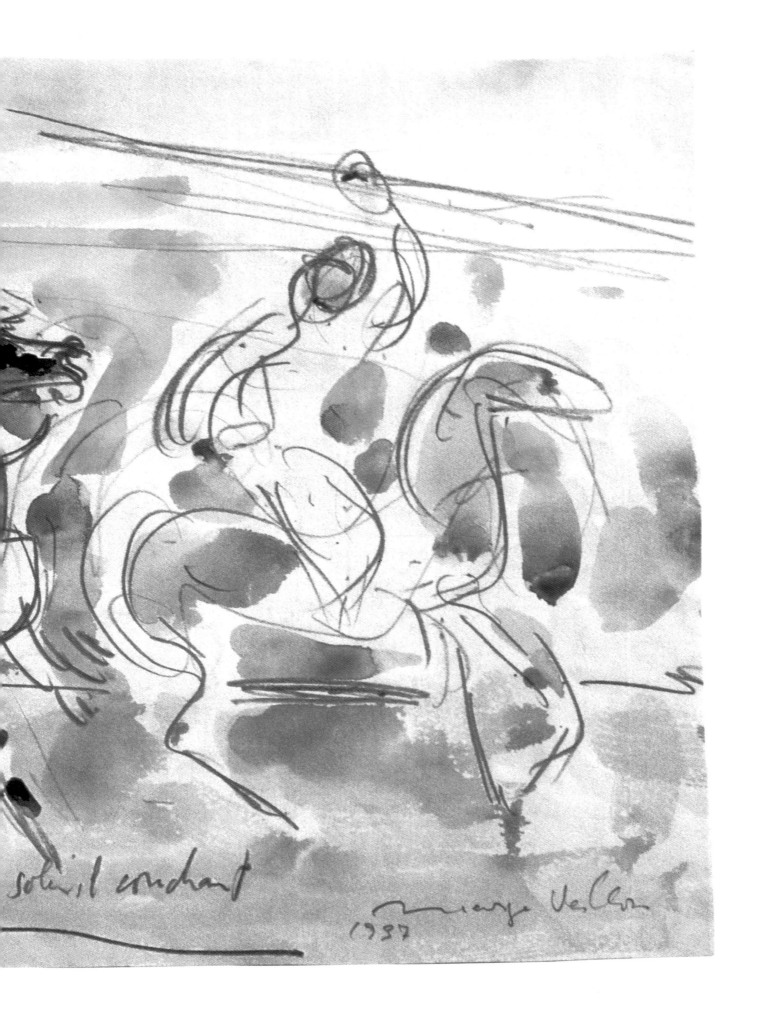

soleil couchant

George Veillon
1987

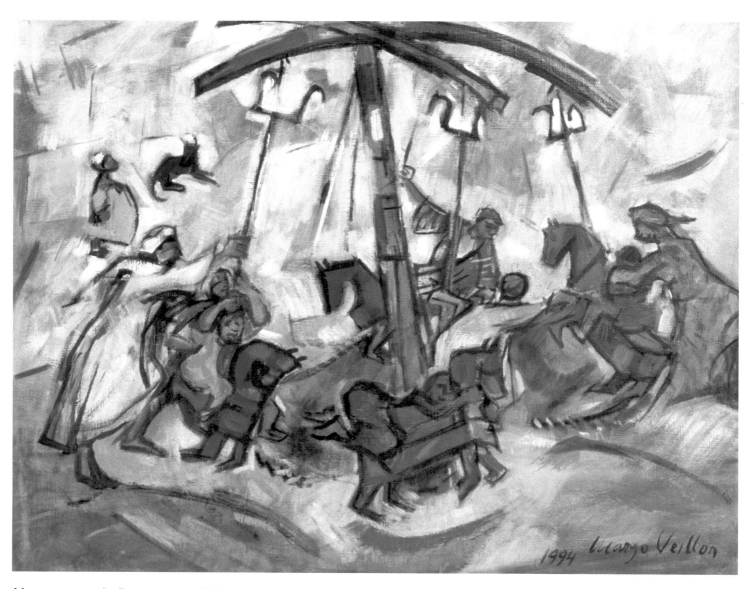

Merry-go-round, oil on canvas, 68x87, 1994

Introduction

Returning from a two-year stay in Paris, Margo Veillon rediscovers Cairo, where she was born, and Maadi, the isolated suburb where she settled some years ago. We are in 1931. After a rich, tumultuous, and inspirational parenthesis in the cosmopolitan artistic capital of the age, she immerses herself in the life of the Egyptian villages. There are still the regular journeys along the Nile and abroad, but Veillon responds uniquely and artistically to the call of the traditional life of the villages. She puts all her energy into it and develops the technique taught to her by a Russian painter she encountered in Montparnasse: observe the subject and let the hand move by itself.

The call comes in concrete form, some evenings, from the nearby village of Maadi. She hears the first notes heralding a wedding, a *mulid* celebrating an Egyptian saint, or a *subua*, the celebration held on the seventh day after the birth of a child—and she has already begun the journey through the never-ending cycle of Egyptian festivals. Through long evenings and long years, she fills notebooks with sketches, drawings, and notes, and takes numerous black-and-white photographs—all to be reused later in her studio. For the art of Margo Veillon, so alive, so instantaneous, is also an art of reworking (the stroke itself is often intensified and constitutes in effect her artistic signature). There is no paradox in that. So many drawings and sketches, and then paintings, cannot exhaust the luminous sources of inspiration to be found in certain gestures and poses. She does not act as a photojournalist, even though one may claim today that the vast number of sketches constitutes a monumental description of Egypt, or, more especially, of the life of the Egyptians. What she is constantly striving to reproduce is the act, but with its movement; the musicians, but with their music; the dancers, but with the dance itself. In short, not a snapshot, but that which animates it, the part of life that it conceals and reveals, the echo

it emits. Thus it is that one never grows weary of discovering these watercolors or drawings that have the simplicity of a picturebook, the gravity of a song, and the depth of silence.

The Celebration of Looking

At first sight, the drawings and paintings of Margo Veillon appear simple in comparison with the often tormented or complex art of the twentieth century. Nevertheless, if the art of that century has left us a legacy, it is one of looking. If we pay attention to it, it teaches us to see anew that which is truly hidden by the obviousness of simplicity, of the everyday, or of too much humanity—everything we no longer know how to see. And Veillon takes part—notably with the works assembled here—in this great celebration of looking. There is so much to see in this world stuffed with images: we still need to know how to see. A flute-player is not a flute-player: he is a thousand ways of saying—alone and with his melody—the world in its entirety.

In each scene of a festival, there are all festivals, or better still there is the song of the world as it wells up. If we believe we are observing through these pages only a remarkable description of Egyptian festivals, we are captured little by little by these scenes that come back into our world, that become our world. Look at the veiled women in the cemeteries. Look at the pampered bride. Look at the horses and riders. The painter

has given the gift of her looking to her paintings. In short, the vision of the painter (the very beautiful photograph of the artist among the villagers speaks volumes here) stares us in the face.

The Song of Lines and Colors

The twentieth century in art was inaugurated by two fundamental movements of deconstruction in painting, one through form, the other through color. Having come close to both in Paris, in her new start in her studio Margo Veillon essentially exploits the former, even if here and there she lets only patches of color give her painting its force. It is the work on form that, despite her real gifts as a colorist, occupies her primarily, as shown by the cover of this book: the two horses and their riders are caught in the net of tents transformed into triangles of color that form a kind of mosaic of festivity. This deconstruction ("a derivation from planes," she writes in the margin of one of her drawings) is in fact no more than a way of looking at reality, as even the photographs of these scenes show a similar distortion through the lens. On a deeper level, it is the stroke that defines the style in the watercolors and oils of Margo Veillon. The clear or the effervescent stroke lets the unfinished in both drawings and oils testify to a work well done and well finished. Freedom in the drawings allows the artist not to labor the point. She supports an outline with a deeper black, sometimes even using Indian ink, as a spot of color elsewhere balances

the composition. For if we are to talk of deconstruction, this is primarily a method of bringing out the lines of strength and points of support. And the scenes remain remarkably composed (and drawn) in the classic sense of the term—some could be illuminations.

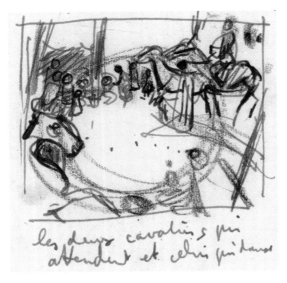

Festival studies ("two horses waiting and one dancing"), detail

Most of the drawings stay happily in the realm of the sketch. This is not to say they are not finished. The artist's style, her defining feature, is to not interrupt movement, to leave a work in progress to be taken up later, to suggest a vision of the world.

The Artist's Music in Miniature

Music and dance fill the pages of this book; it is all about dancing horses, stick dances, flutes and drums, the merry-go-round, or the funerary dance of the weeping women who smash their bracelets. But how to paint these two arts, when the one addresses hearing and the other is a eulogy of the body in movement? It is a secret hidden in the drawings. The painter's art does not consist in reproducing in fine detail the tableau before her eyes as a student of folklore would. Nor is it a case of dissolving the scene in a vague and more

or less abstract impression. Margo Veillon, beyond these two reefs, tries to reveal the source of a movement, or the energy that animates it. "The secret of the art of drawing," wrote Leonardo da Vinci in his *Treatise on Painting*, "is to discover in each object the particular way in which a certain flexuous line which is, so to speak, its generating axis, is directed through its whole extent, like one main wave which spreads out in little surface waves." One finds this approach in Margo Veillon: the line points up something more secret, behind the movement. It is music in miniature that animates the work, music that comes from the undefined richness of forms and colors.

In this celebration of looking, it is the poetry of the world that we hear.

The images in this book, dating from the 1930s to the 1960s (apart from the oils, which are more recent), show how much popular festivals and painting have in common. Both are at the same time a gift and an investment, both create another world, and both are a way of living. The work of Margo Veillon collected here is proof of that.

Bruno Ronfard

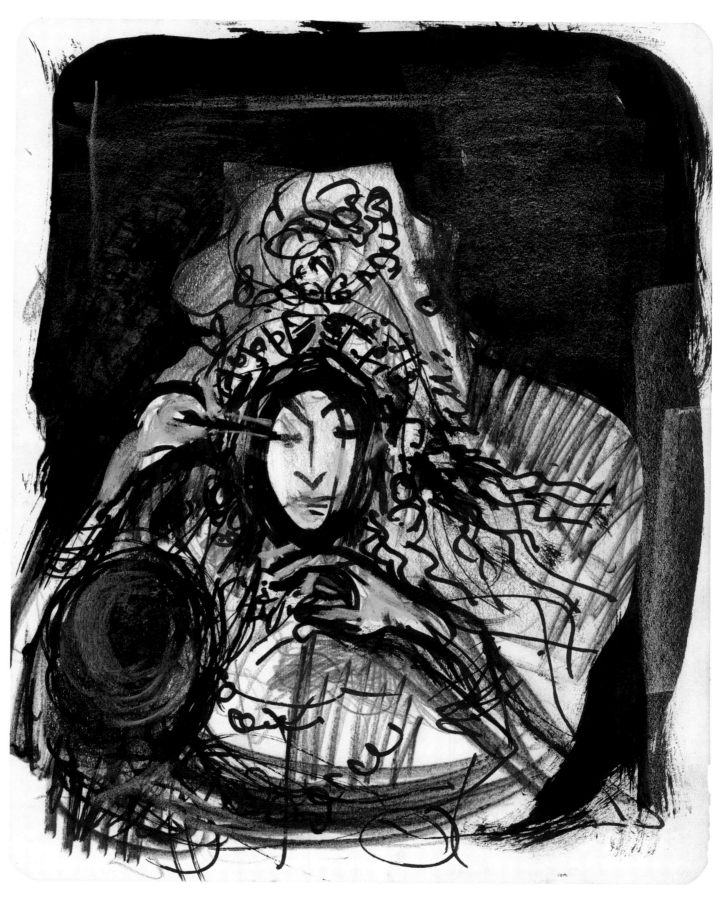

The bride's make-up, ink and pastel, 28x21.5

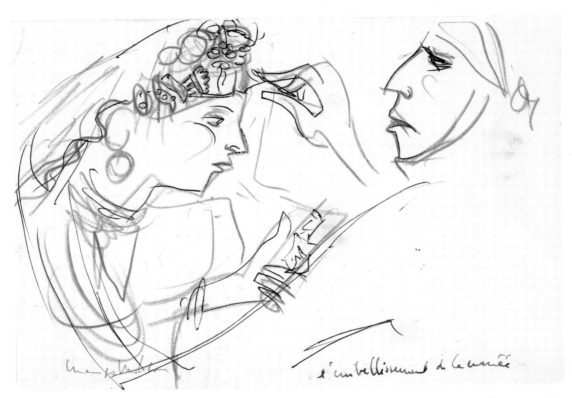

Decorating the bride, pencil and ink, 17x24

Weddings

Here, marriage is organized essentially around two themes: the slow procession of the bride and the articles that will furnish the marital home, and her embellishment that goes so far as to make her face disappear. And all this to the rhythms of songs and dances, to the point where—in the drawing on page 13—the moving process is a veritable waltz.

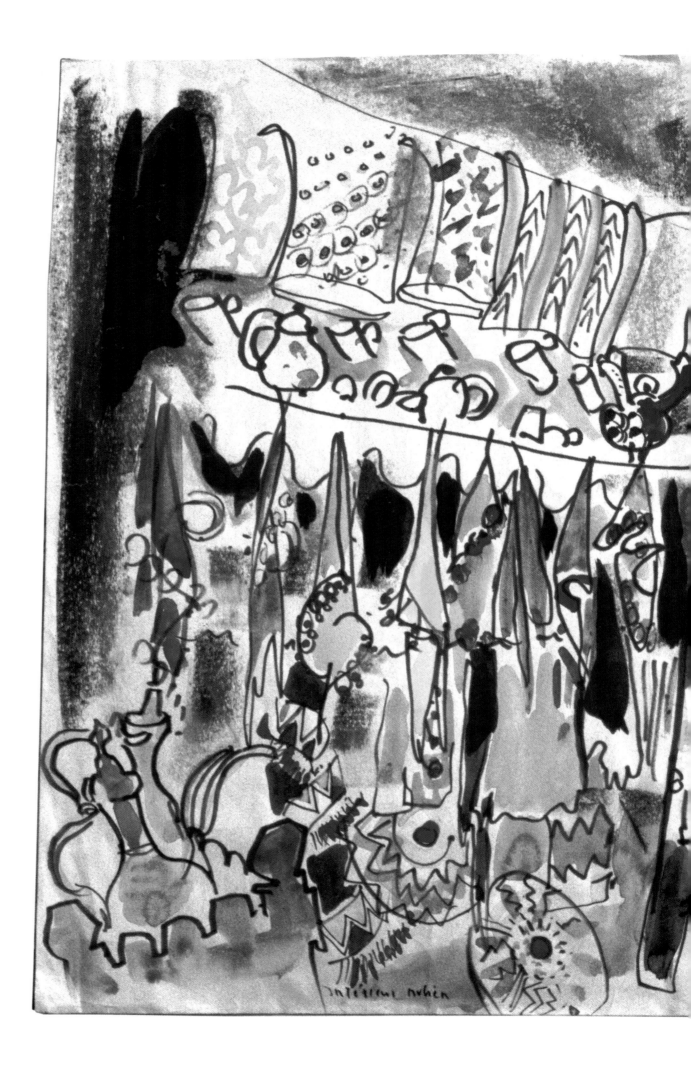

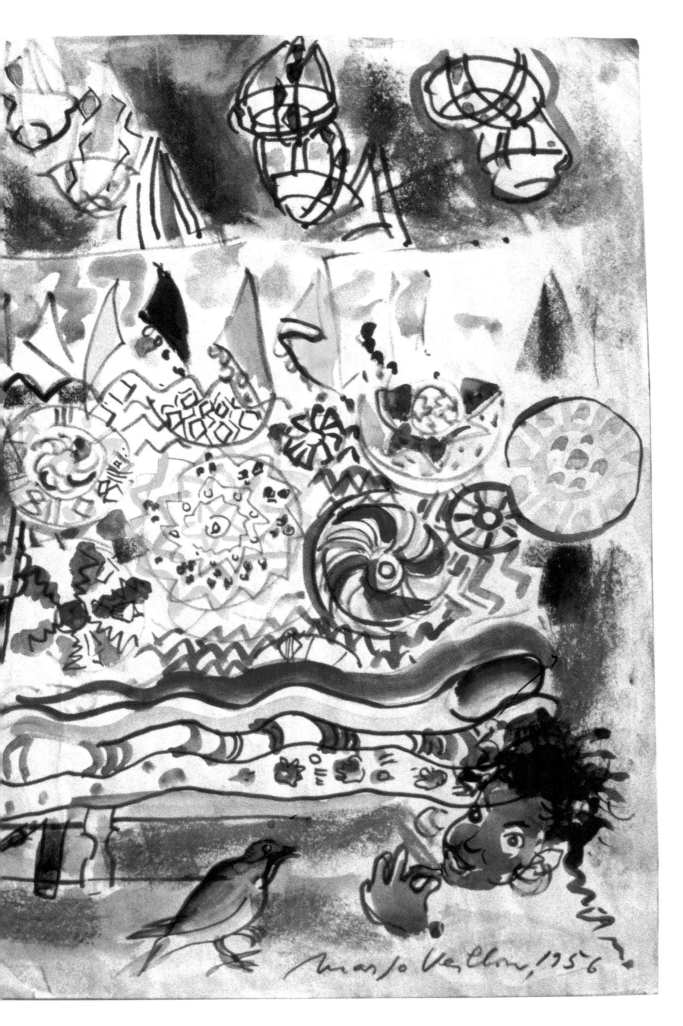

*Festive room
in Nubia,*
ink and watercolor,
49x67, 1956

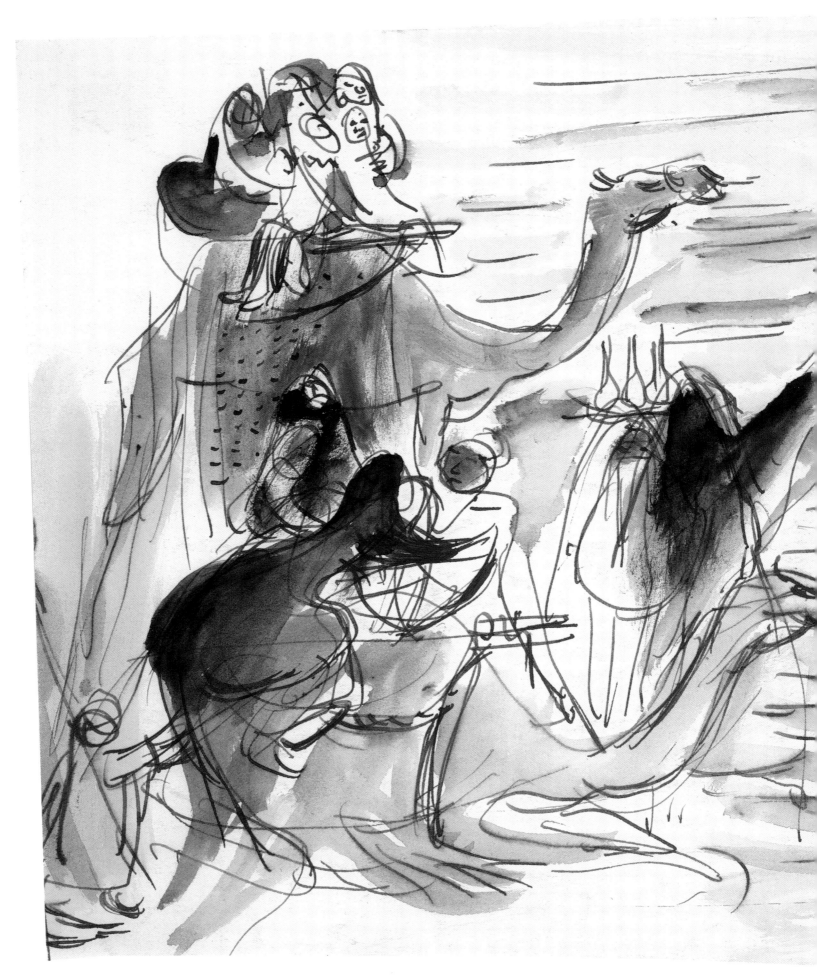

Transporting the bride, ink and watercolor, 21x36

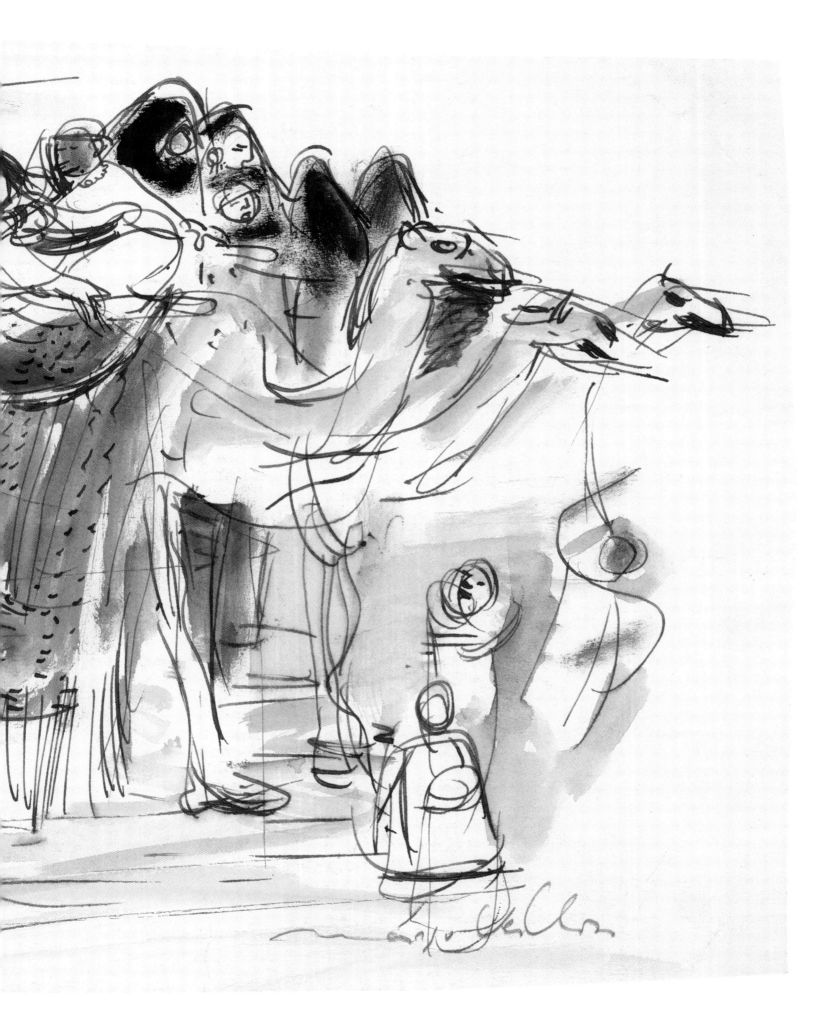

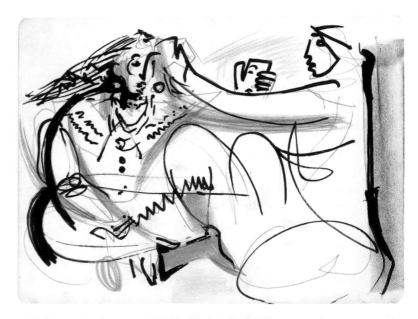

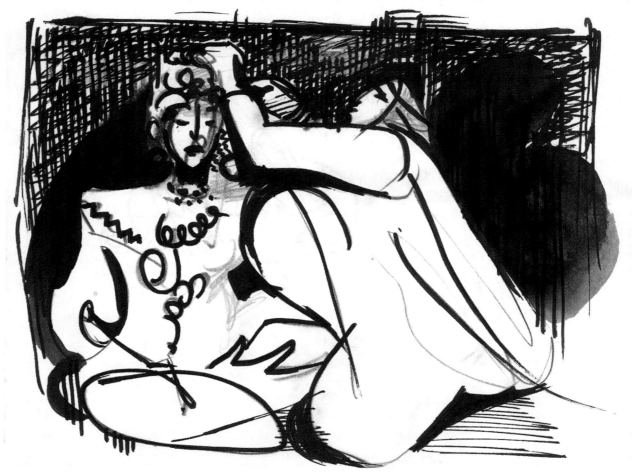

10

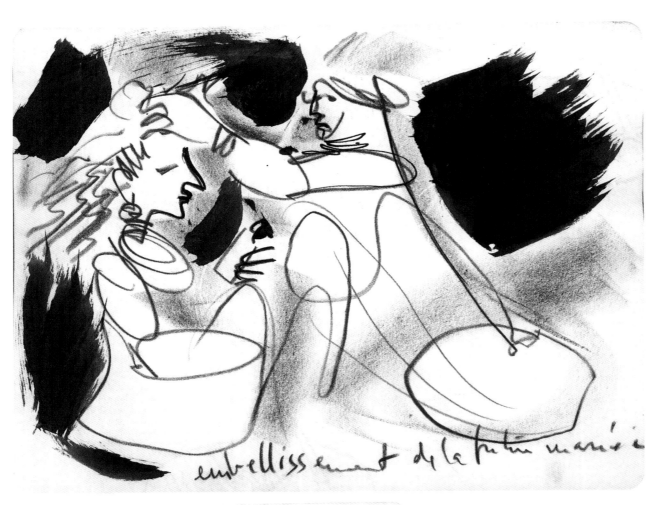

embellissement de la future mariée

Four stages in the decoration of the bride,
pencil and ink, 21.5x28

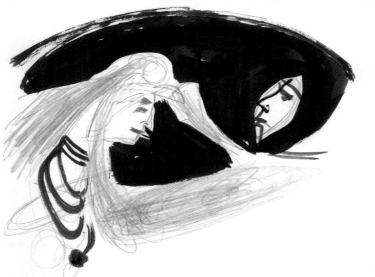

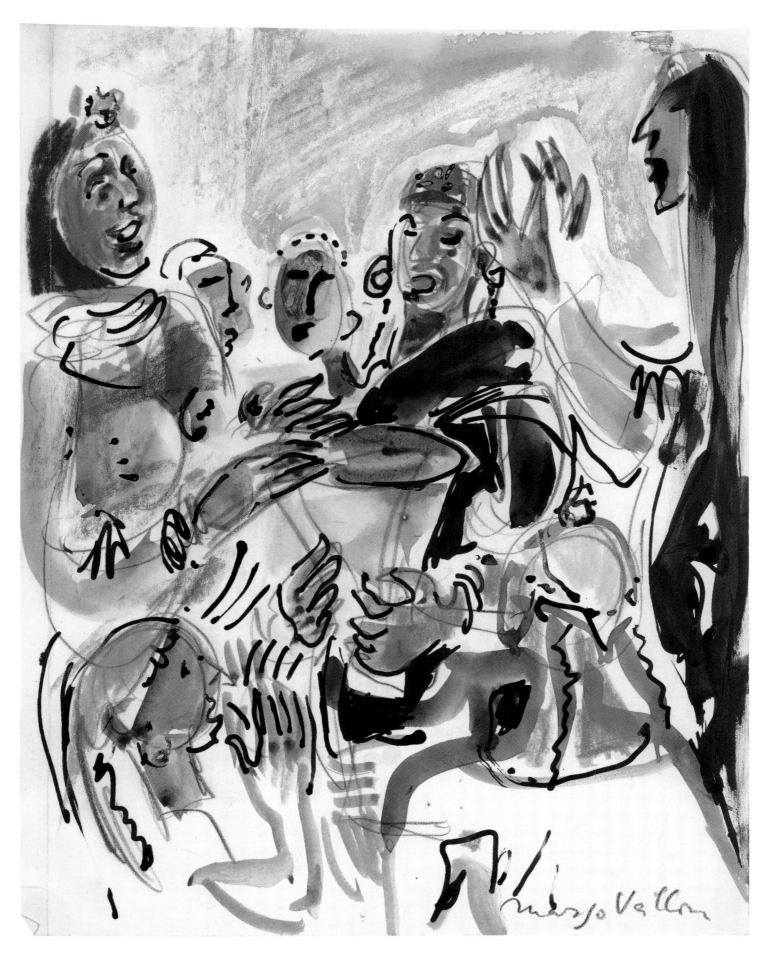

Women's songs, pencil and watercolor, 31x24

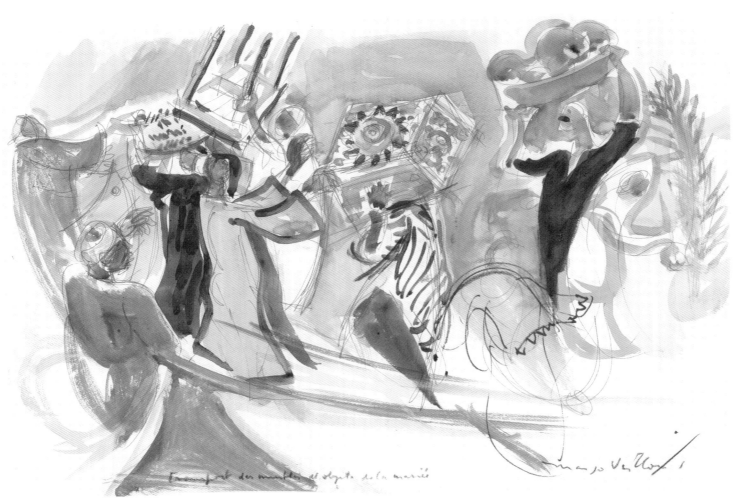

Transporting the bride's goods, watercolor, 33x47

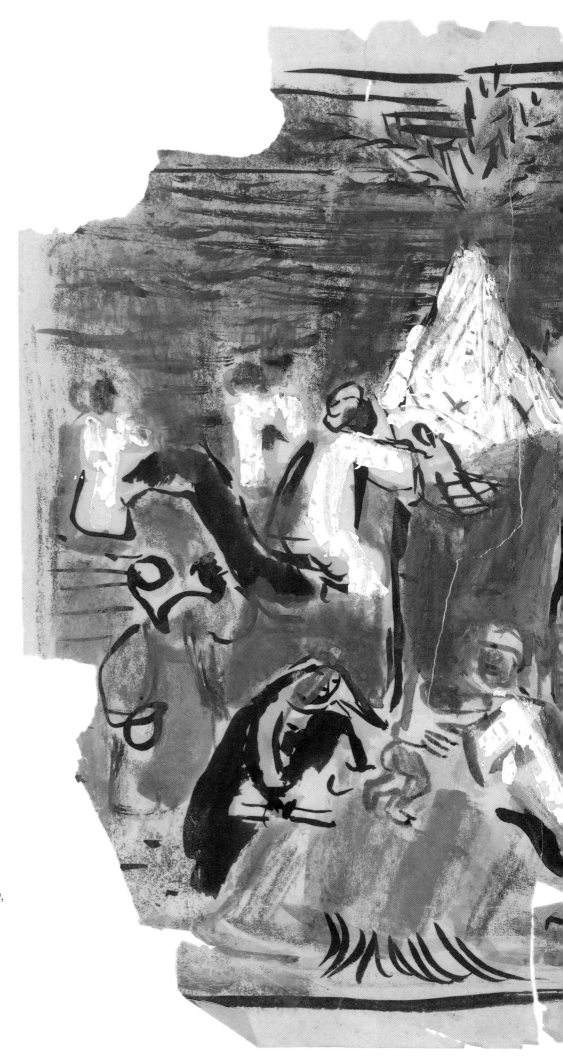

The bridal procession,
oil on calque, 29x36

14

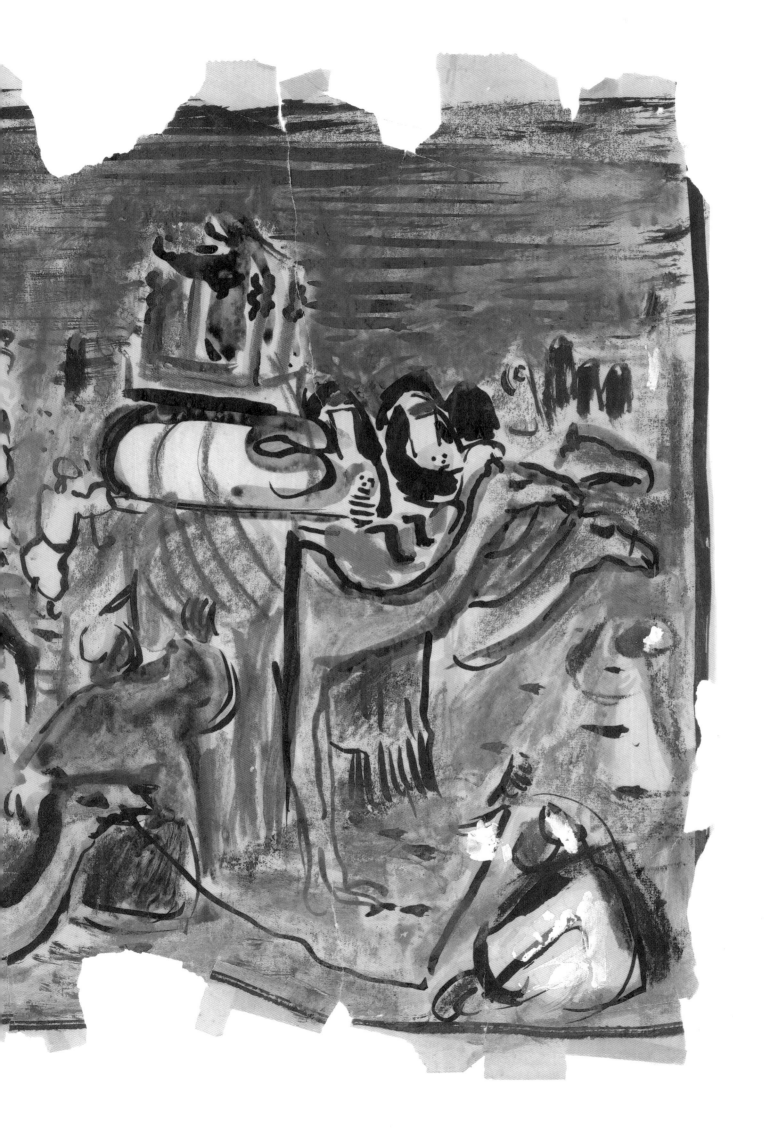

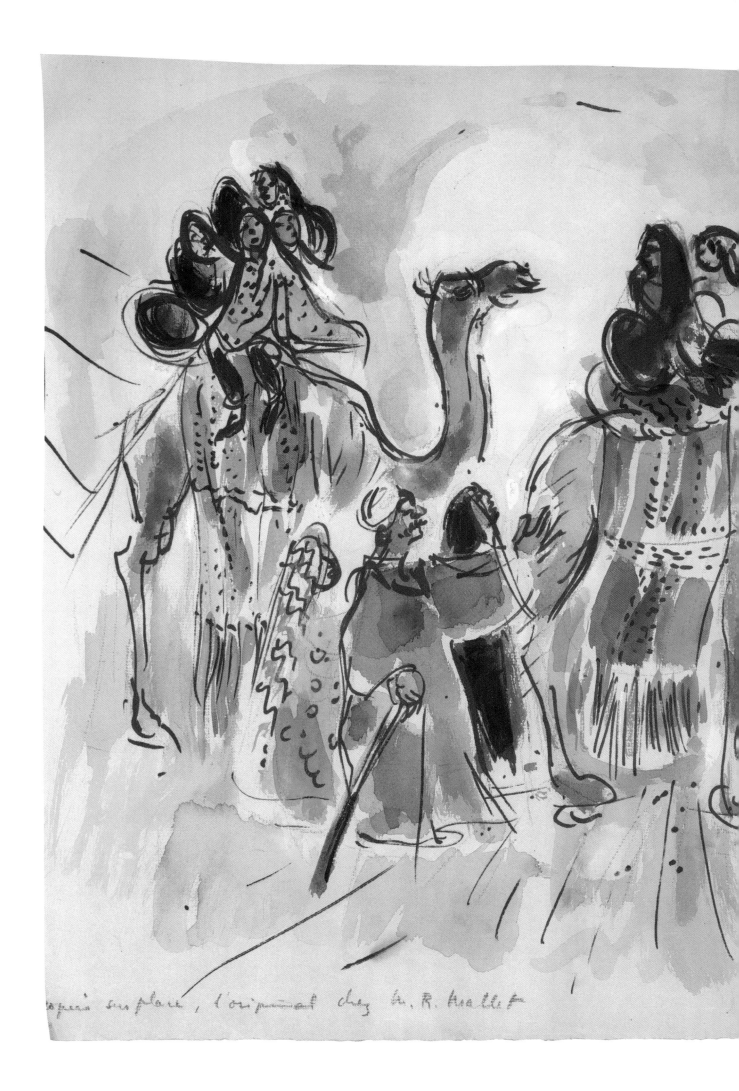

copié sur place, l'original chez M. R. Mallet

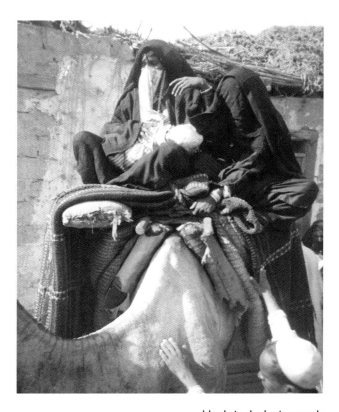

Undated photograph

The bride on her camel,
watercolor, 42x49

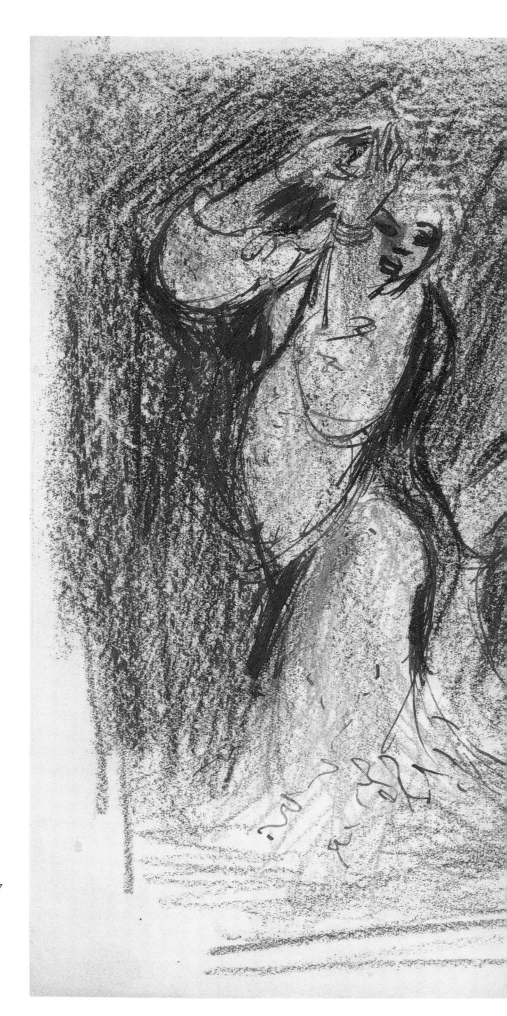

Popular dance, pencil, 21x27

18

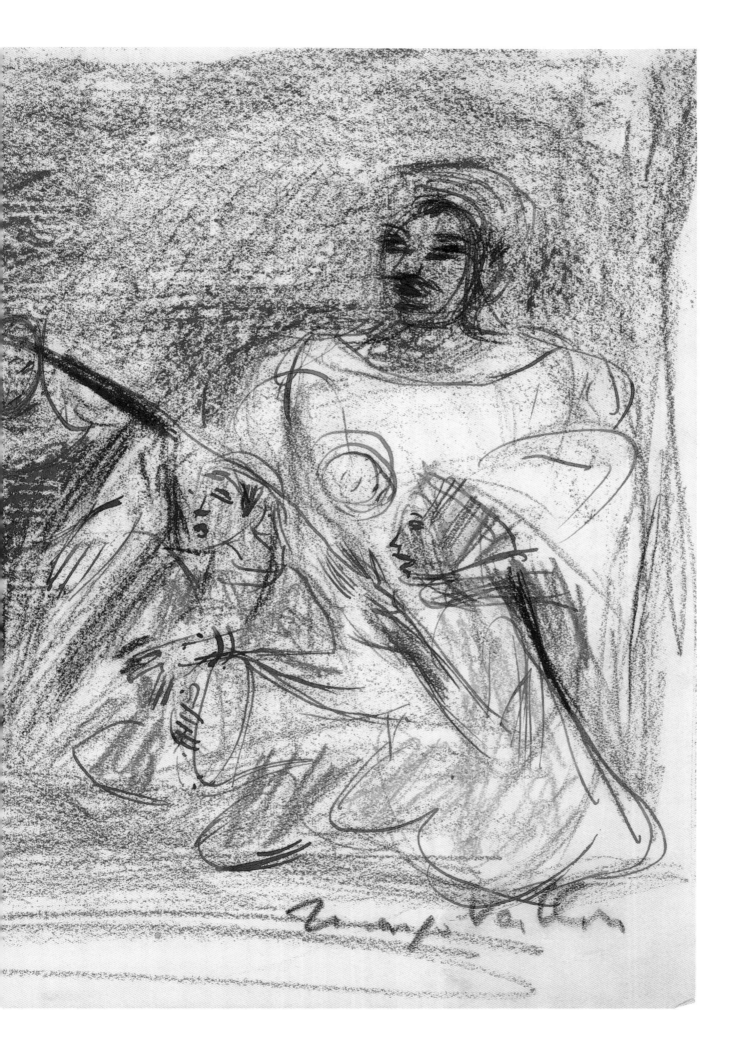

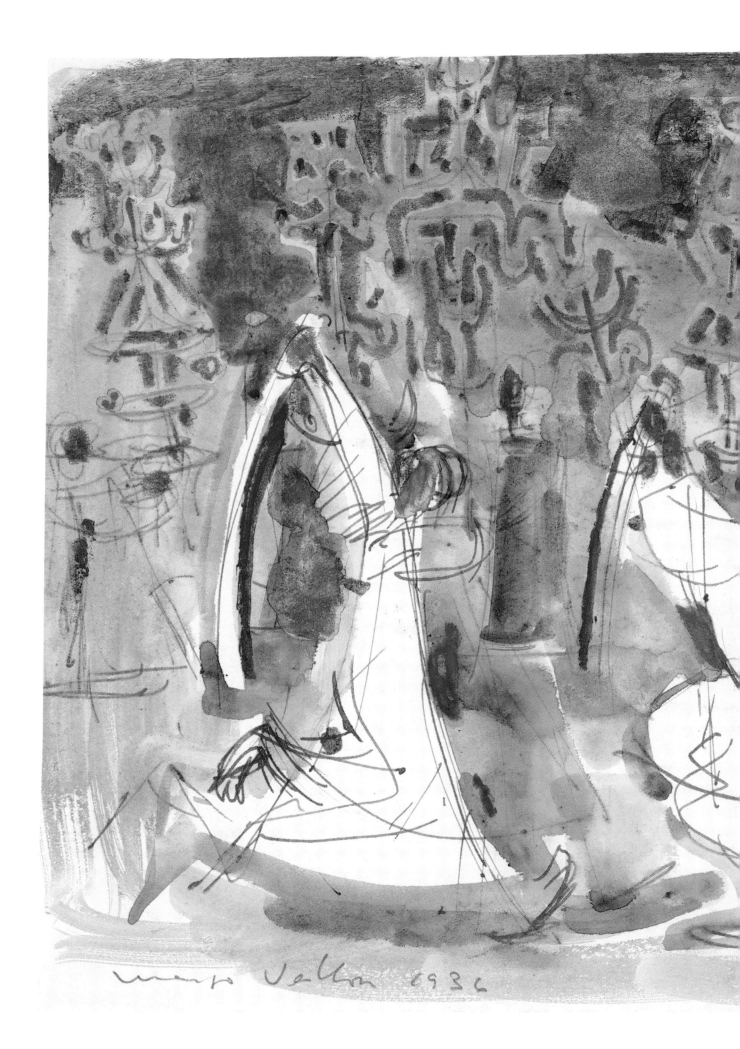

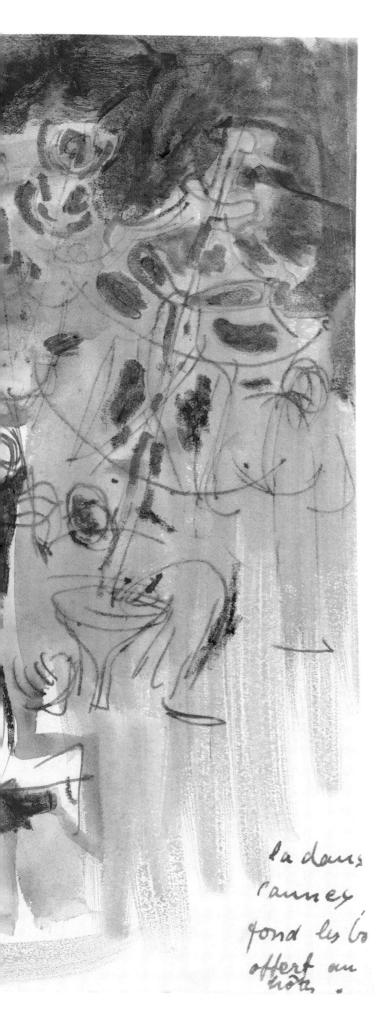

*la dans
l'anney
fond les b
offert au
hôte.*

Stick dance for the bride and groom,
mixed media, 22x25, 1936

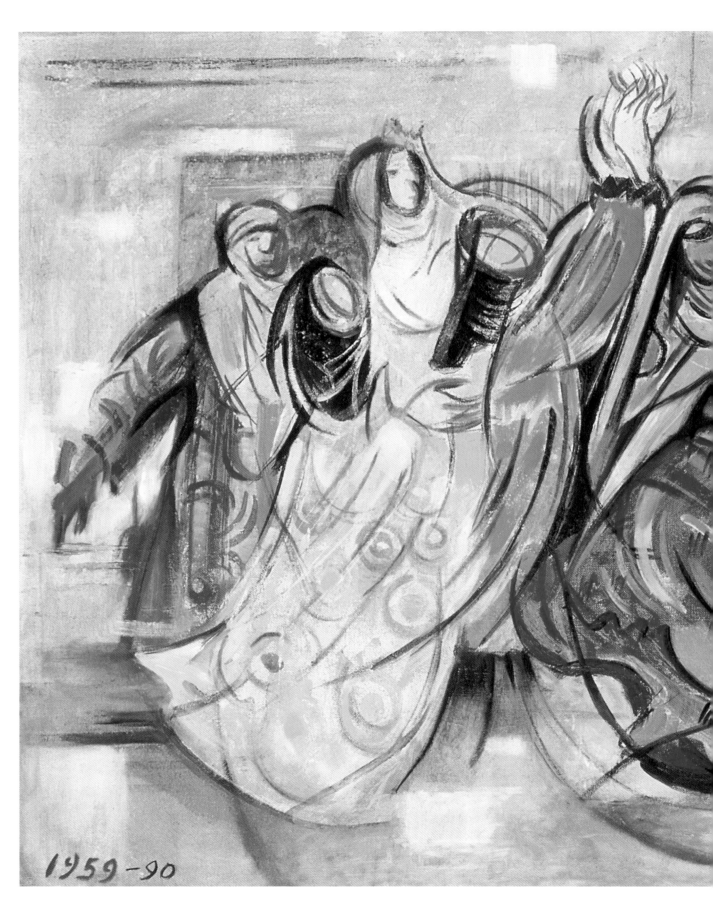

Women dancing, oil on canvas, 73x116, 1959–90

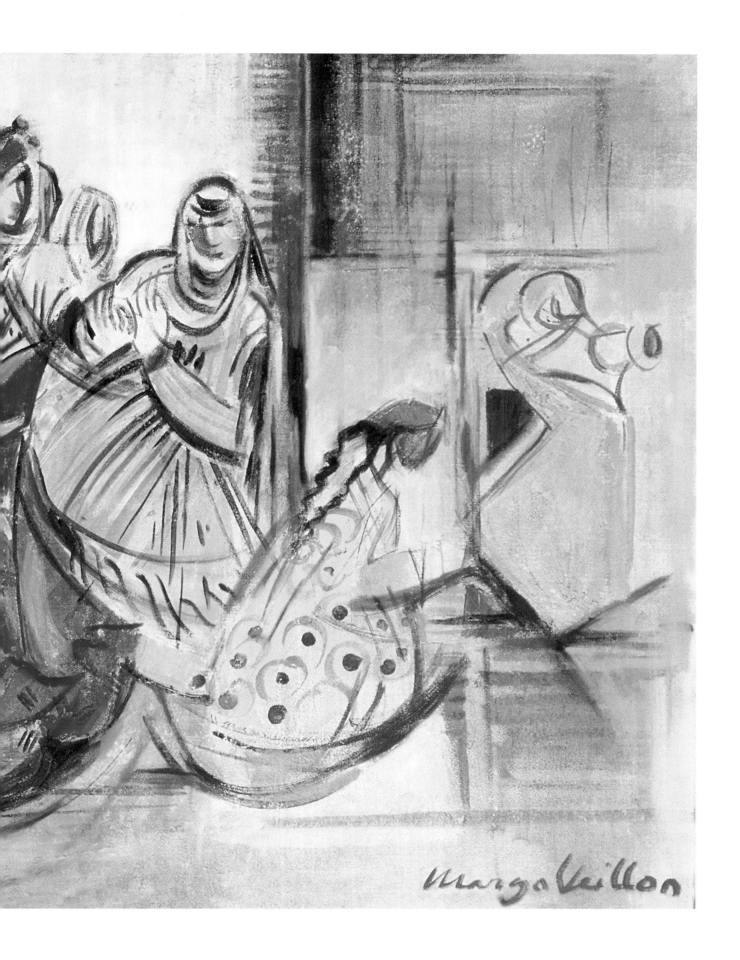

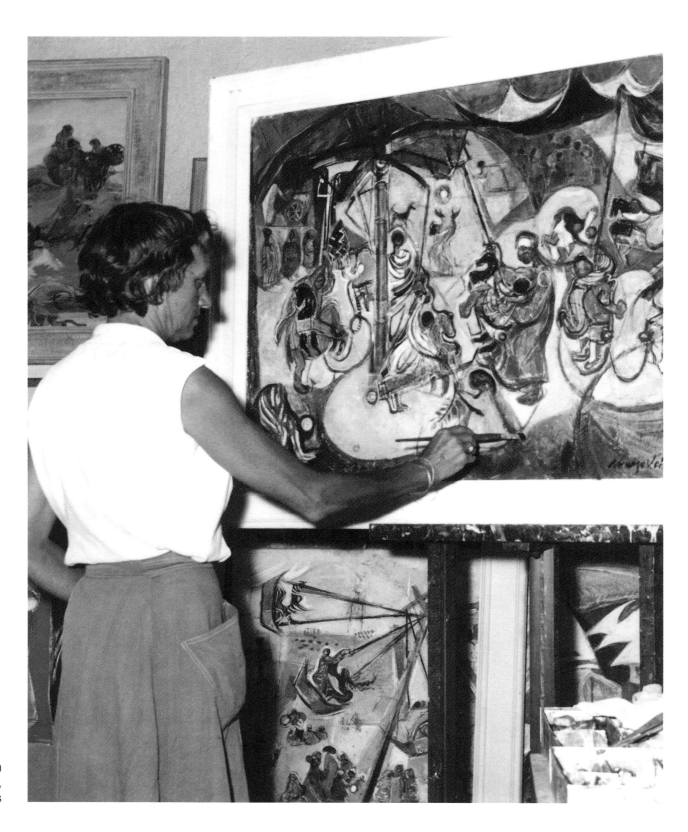

Margo Veillon
in her studio,
1950s

The Mulids of Egypt

Only during the worst periods of its lengthy history has Egypt ever been rendered so lifeless as to deserve those depressing tourist-industry adjectives, such as "eternal" and "unchanging," that suggest a kind of picturesque cultural inertia. When the great stone bulks of the pharaonic temples were built, for example, one of their functions was precisely to make an impressive contrast with the mutability and ephemerality surrounding them, the flimsy and seasonally improvised dwellings of generations of simple folk.

They symbolized the permanence of the divinely exceptional, not the fragile unpredictability of actual human norms or the topsy-turviness that is ordinarily the rule in day-to-day real life; and even so they themselves were often built using the remains of older structures that had been allowed to decay or even willfully demolished. It sometimes seems, in fact, that in Egypt mere physical traditions have been made largely in order for latecomers to destroy them. The search for cultural survivals is thus likely to be quite disappointing, producing results, if any, that are unconvincing, trivial, or simply boring, as a few recent books amply testify.

Perhaps such was not always or invariably the case. It is true, for example, that E.W. Lane, the greatest ethnographer of Egypt, often found in the manners and customs of early nineteenth-century Cairenes an explanation for fourteenth-century references in the Arabian Nights. But one of Lane's major motives in making his ethnographic observations, based on seven years of residence between 1825 and 1835, was to record for posterity the folkways he saw vanishing daily before his very eyes. In *Manners and Customs of the Modern Egyptians* (1836) Lane thus details methodically the Egyptian public festivals he saw and participated in. His descriptions run to well over one hundred pages and remain the best and liveliest on the subject ever written.

The two most important annual public festivals in Lane's time were the Return of the Caravan of Pilgrims from Mecca, which took place toward the end of the lunar (Islamic) month of Safar, and the Opening of the Cairo Canal (the Khalig al-Masri), which occurred sometime between the first and the eleventh of the solar (Coptic) month of Misra (i.e., between 6 and 16 August). Both these festivals had occasionally been mentioned or cursorily described during earlier centuries by Arabs or Europeans passing through Cairo. And both, with all their colorful appurtenances, have long since completely disappeared, leaving only written records behind: the Canal was filled in not long after Lane's death, then paved over to serve as the street that now bears its name; and the next few decades saw pilgrimage caravans inexorably replaced by motorcades, steamers, and chartered jets.

Amidst all such shifts and changes, however, two immaterial elements have constantly survived and remain perennial in Egypt, as Lane knew very well: piety and good humor, both of which are abundantly evidenced in that most characteristic of all Egyptian folk festivals, the *mulid* (more correctly *mawlid*, plural *mawalid*), the putative birthday observance or celebration of a holy character or saint.

The most famous mulid is a formal and official one, the Mulid al-Nabi or Birthday Festival of the Prophet, which has always remained an official holiday throughout Egypt, however it has been observed. In nineteenth-century Cairo the Mulid al-Nabi was signalized by a sensational muster of

Egyptian Sufi orders quite unparalleled anywhere else in the Arab world. Under the khediviate, the sultanate, and the monarchy (1863–1952) this display was mutated into a magnificent parade effectually celebrating the Muhammad 'Ali dynasty. It was therefore banned by the new Revolutionary government (1952–71), but revived under Anwar al-Sadat (1971–81).

The Mulid al-Nabi has, of course, an unimpeachable historical basis in reality, as do the Mulid Imam al-Shaf'i and perhaps a handful of other similar observances in Cairo. More typically Egyptian, however, are a vast number of mulids that have arisen out of sheer piety acting on a basis of religious tradition. Such mulids typically center on a "shaykh's tomb," a domed cenotaph where the holy figure for whom the mulid is named and whose birthday it is supposed to celebrate is said to be interred. The entombed saint was not necessarily a real person at all, but a powerful figment envisioned or dreamed.

In the course of time, however, the visionary origins of such a saint are inevitably forgotten and a myth comes to be created in which the simple sanctity of dreams is gilded with the false trappings of physical reality. The imagined figment is adorned with a pseudo-biography that "explains" how the body of such a saint—which has in fact never physically existed—came to be such and such a place. The principle in play here is one well known in linguistics: when an allusive idiom survives from circumstances in which it is immediately understood into circumstances in which it no longer makes any obvious sense, it is usually

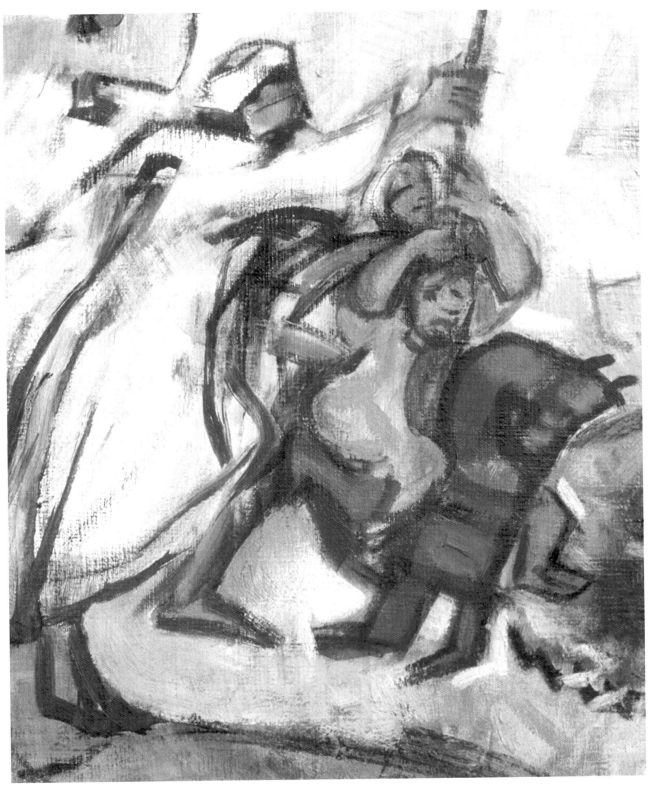

Merry-Go-Round, detail

then "explained" in ways that will make it seem somehow reasonable. It is this process that gives rise to what are called "folk etymologies" in linguistics and to mythology or ideology in politics or religion.

Such Egyptian saints as Barsum the Naked, Ahmad al-Badawi, and Abu Haggag, celebrated respectively in a village just south of Cairo, at Tanta in the Delta, and in Luxor, the ancient capital of Upper Egypt, thus quite clearly had their origins long ago and in vision rather than in historical reality. It is this

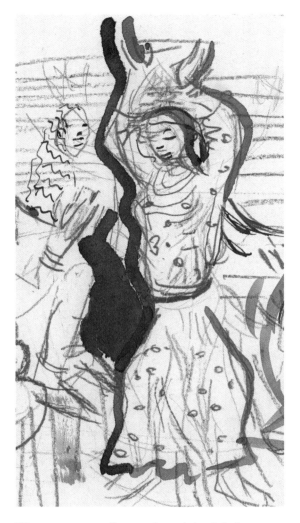

Women among themselves, ink, detail

fact, indeed, that has given them special value, for their mulids in particular are among those that enshrine the very principle of piety, the humble recognition of a deity far above and beyond human entreaty or control. Nor is it accidental that they should also represent real cultural survival: the final performances, in places sanctified by other faiths millennia ago, of religious dramas that now exist nowhere else on earth and will almost certainly disappear within the next twenty years.

Of equal importance with piety at these festivals, however, is good humor, which is wonderfully displayed in the work of Margo Veillon. Like the great fairs of medieval Europe—virtually all of which, unfortunately, were abolished during the nineteenth century, on grounds that they were too rowdy—the great *mulids* of Egypt are pilgrimage sites. They are thus visited on a regular basis by people who take pilgrimage seriously and who therefore devote much time and a great deal of money to the effort, visiting as many sites and shrines as possible. Chaucer's pilgrims would have understood them at once and would have felt more or less at home with them, especially as they gazed together over the multitudinous diversions on offer, sacred and profane, ranging from *dhikr* and prayer to vertiginous rides, intoxicating music, displays of horsemanship, and elaborately festive food and drink.

John Rodenbeck

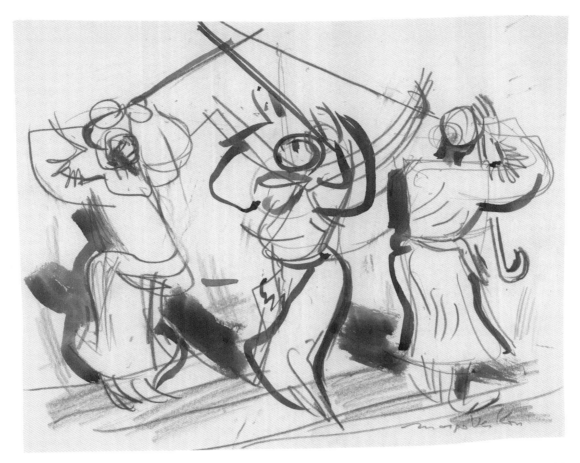

Untitled, ink, 23x29

The Stick Dance

What joy for an artist like Margo Veillon, this stick dance, performed
at weddings and *mulids*! Her crayon excels at depicting the stick
as an extension of the arm or the body that twirls it. And if the tip of
the staff commands the dance, it also structures the drawing.

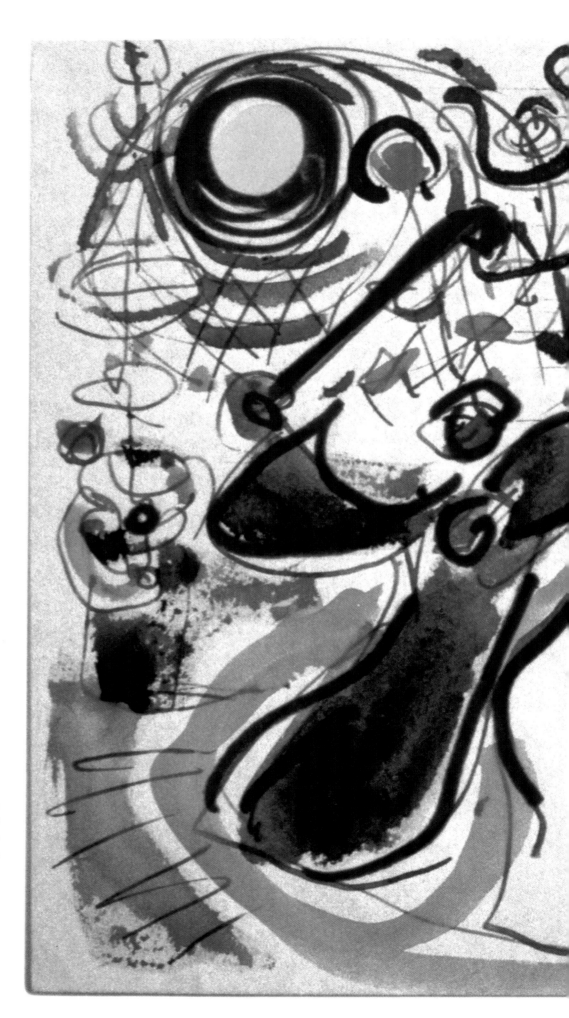

Stick dance on a background of bunches of flowers arranged on wire stalks, watercolor, 15x20

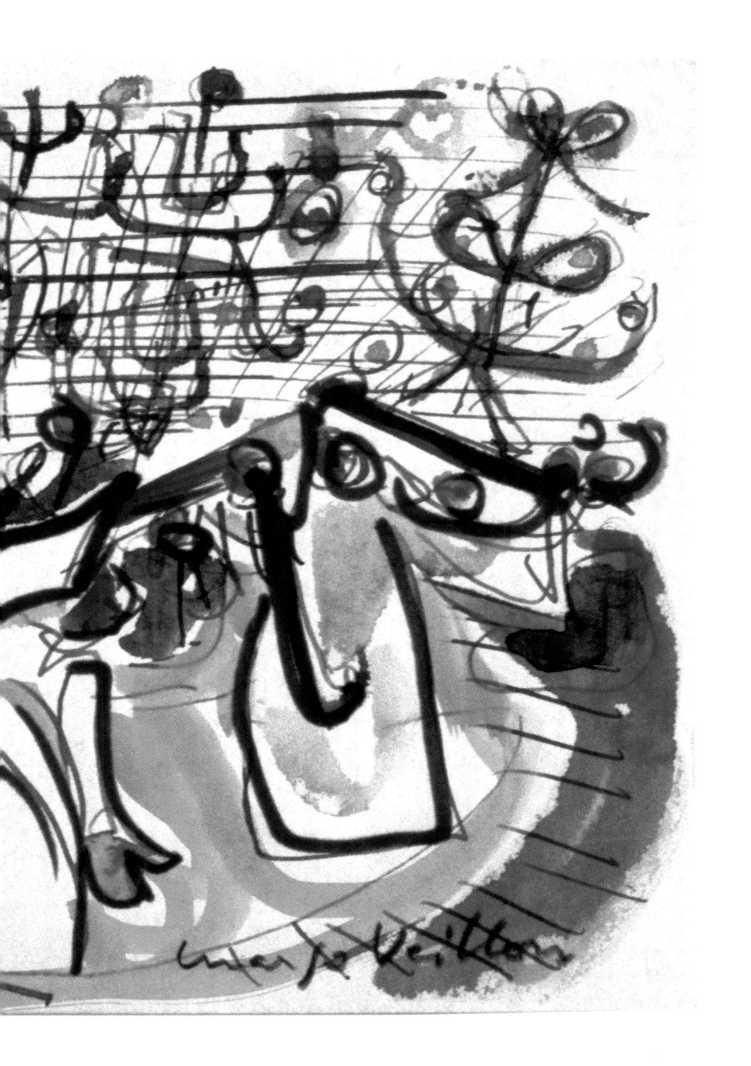

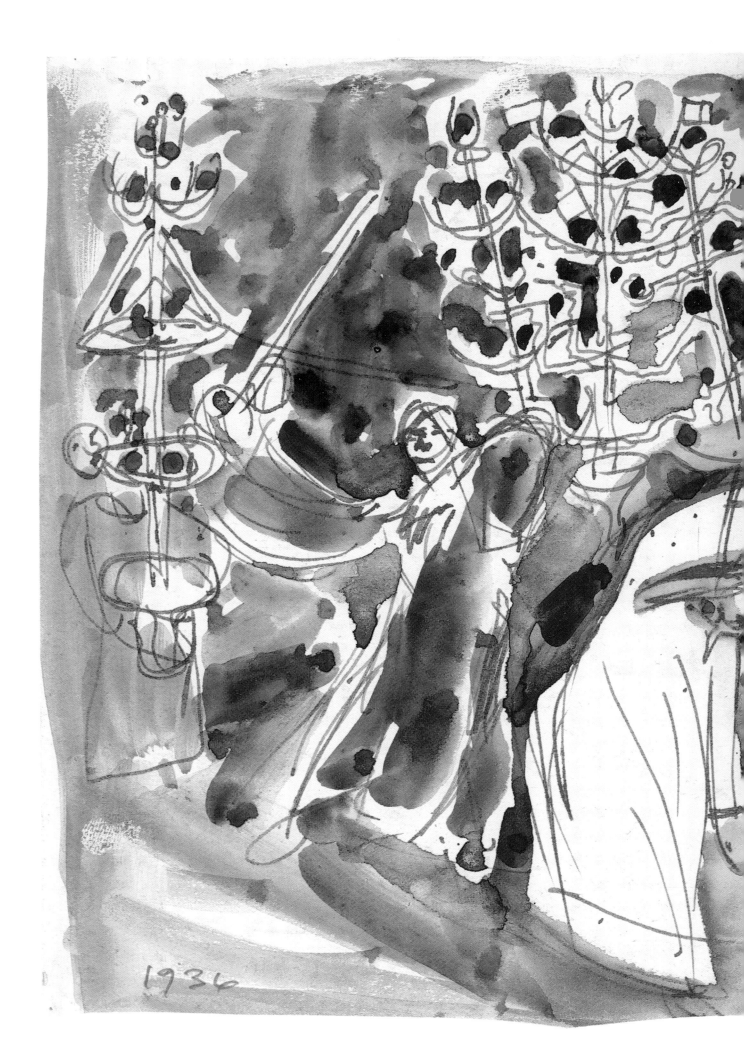

1936

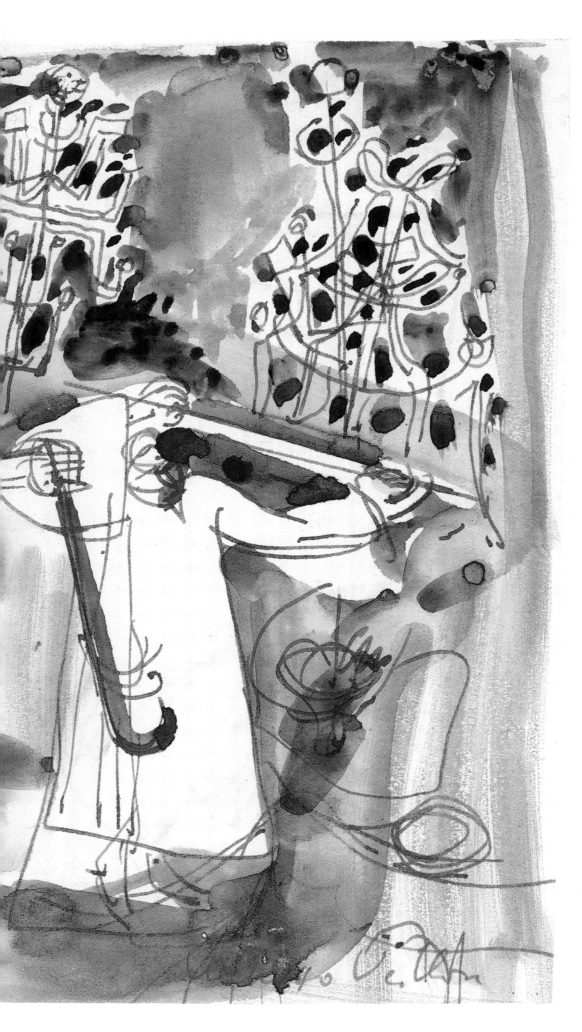

*Stick dance on a background
of bunches of flowers
arranged on wire stalks,*
watercolor and ink, 18x23, 1936

33

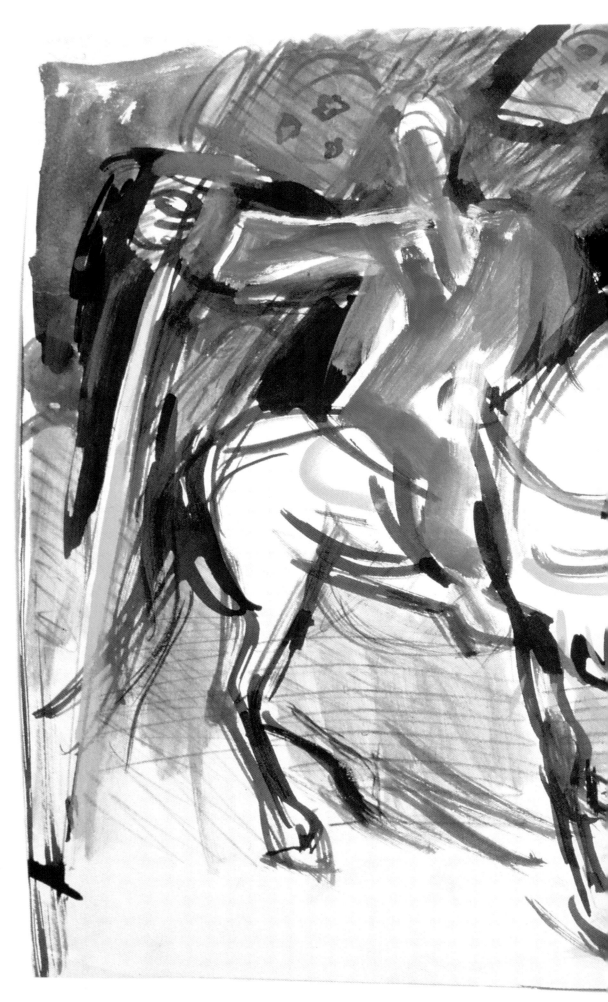

Stick dance on horseback,
gouache, 32x42, 1937

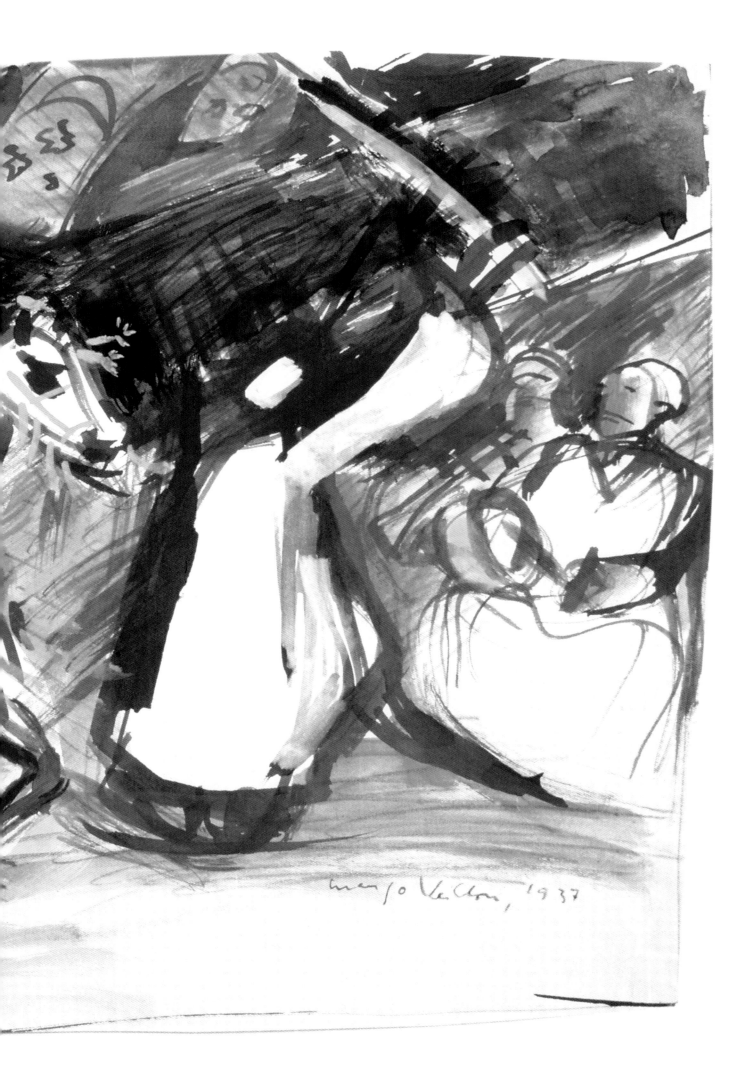

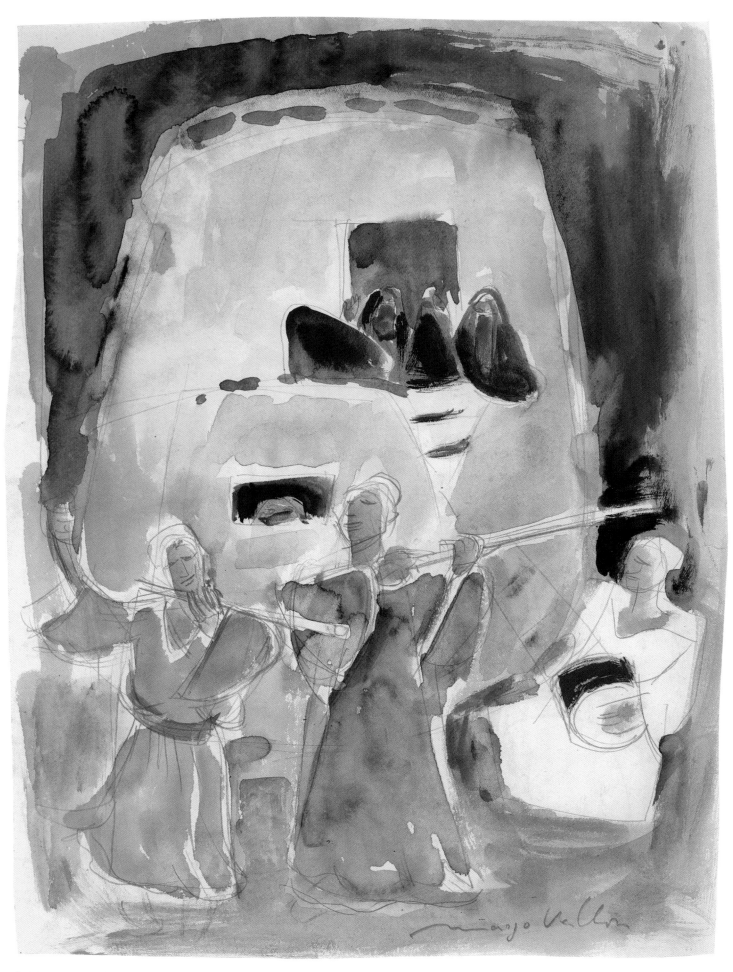

Stick dance with women watching from a distance, watercolor, 34x25

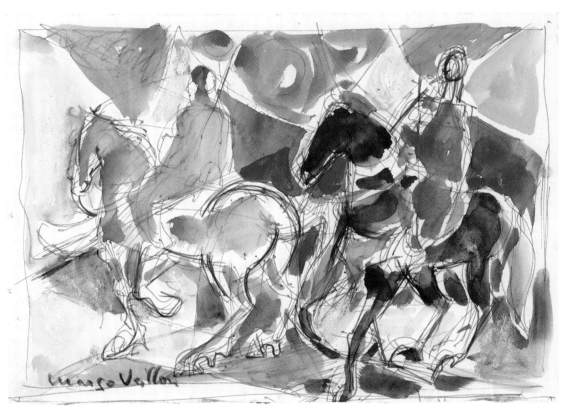

Festival horses, watercolor and pencil, 16x22

Dancing Horses

Festival horses. The artist is fascinated by them: they are all reined strength, tugging at the bit and lifting their croup. "Half motionless, the hindquarters moving," she notes furtively in the margin of a drawing. For Margo Veillon, the horses are an inexhaustible subject in her quest to capture the essence of movement.

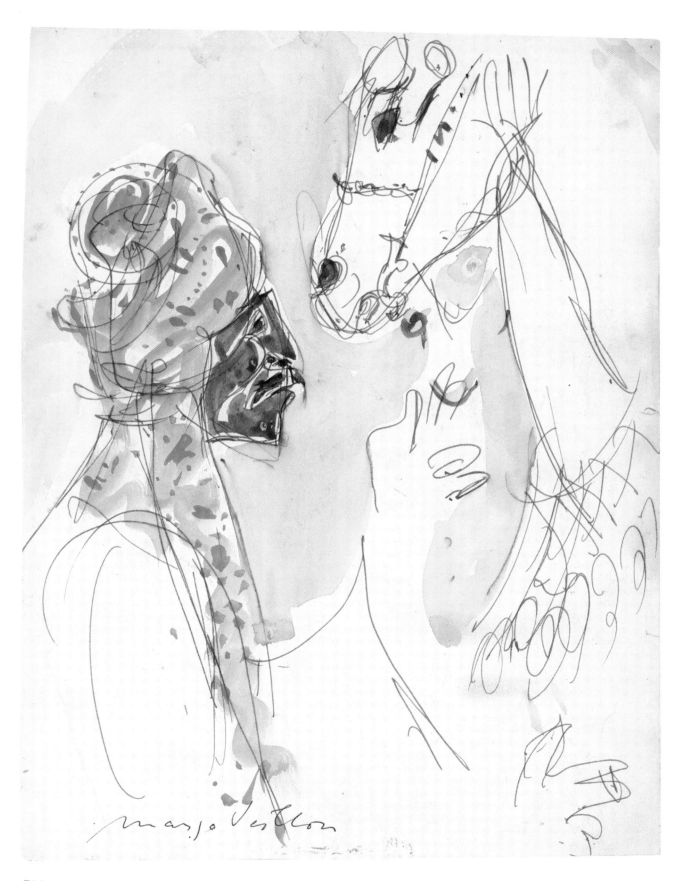

Rider and his mount, watercolor (left), ink and gouache on calque (right), 29x20

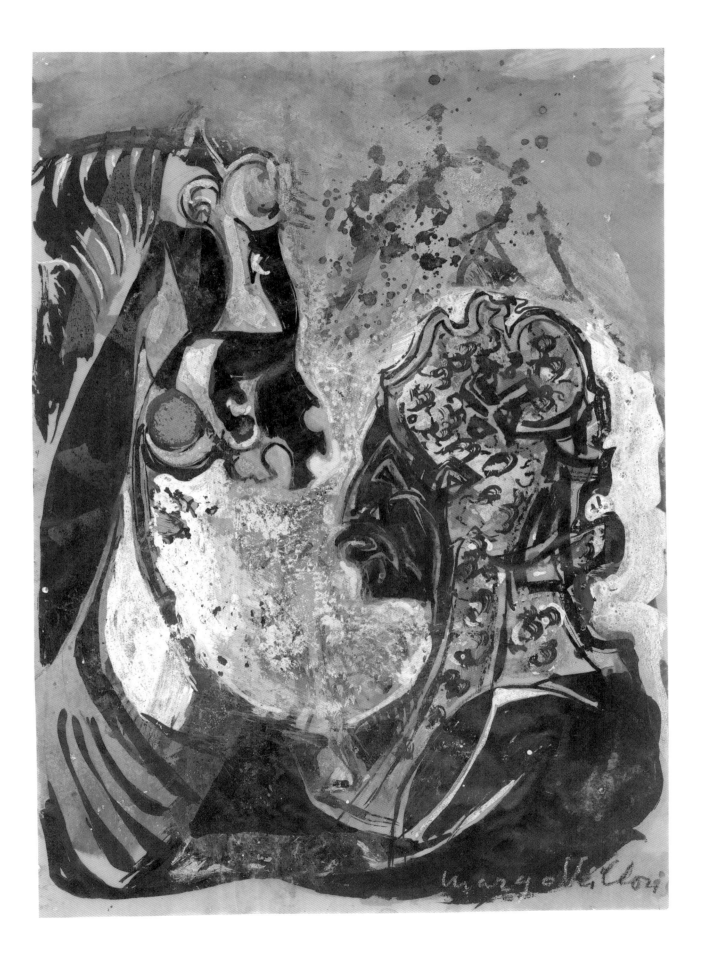

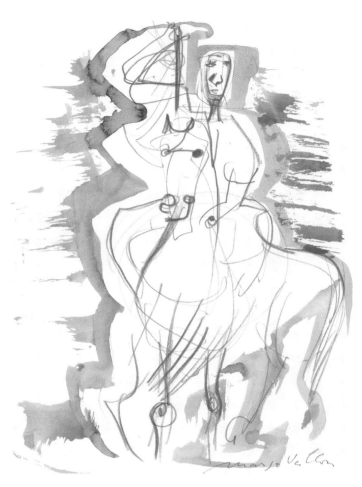

Horses,
ink and pencil,
28x20

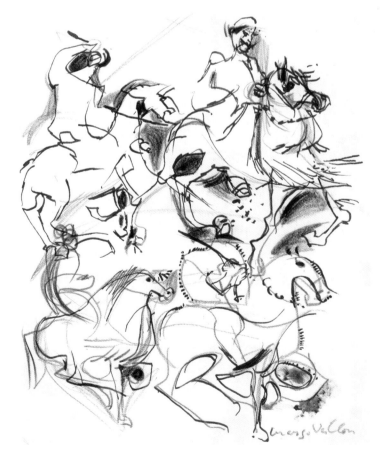

Untitled, mixed media, 36x25

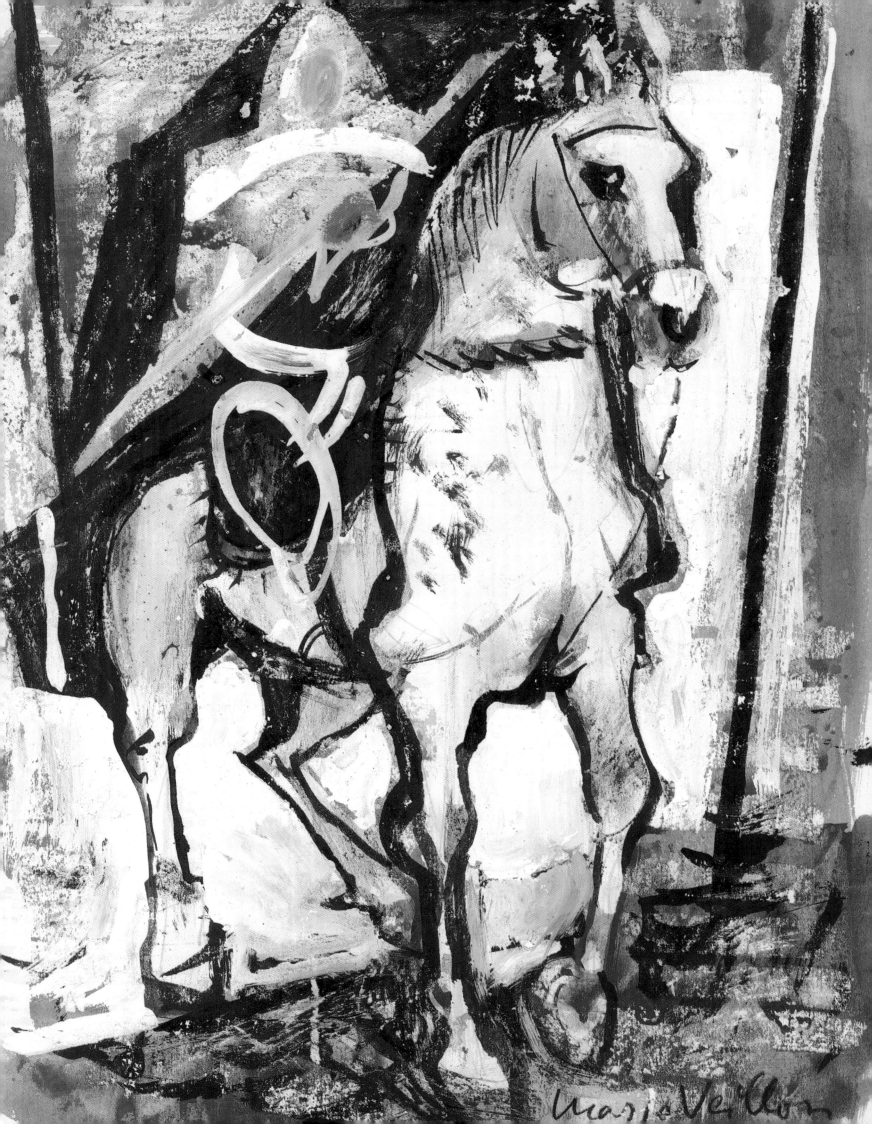

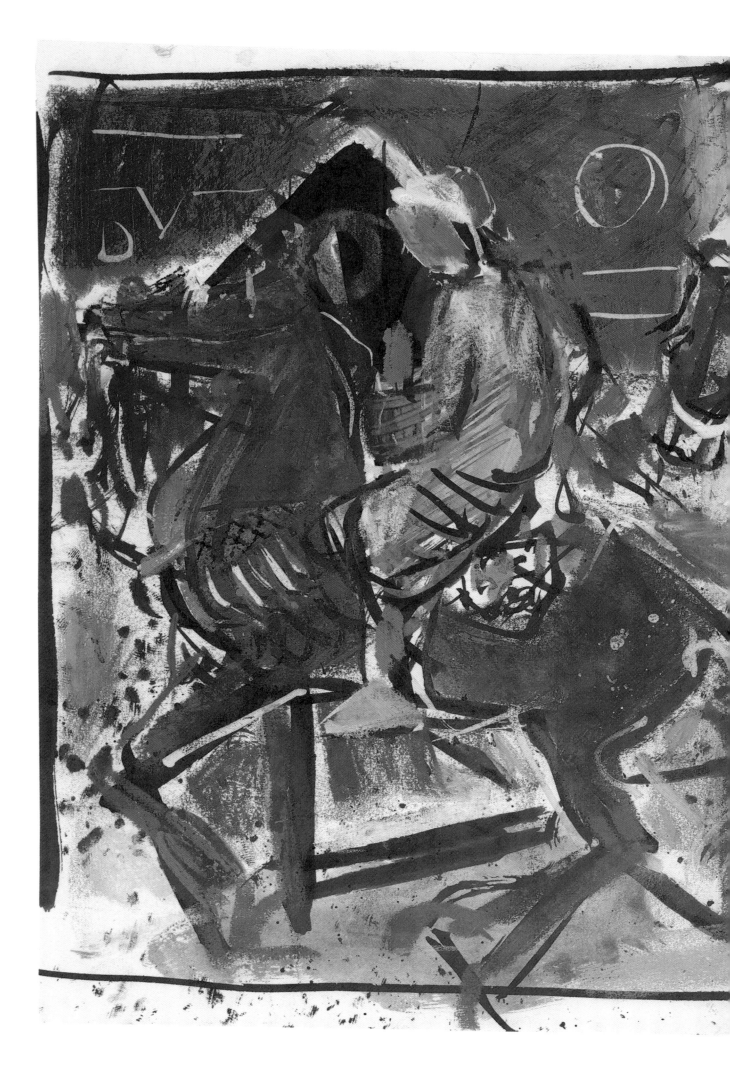

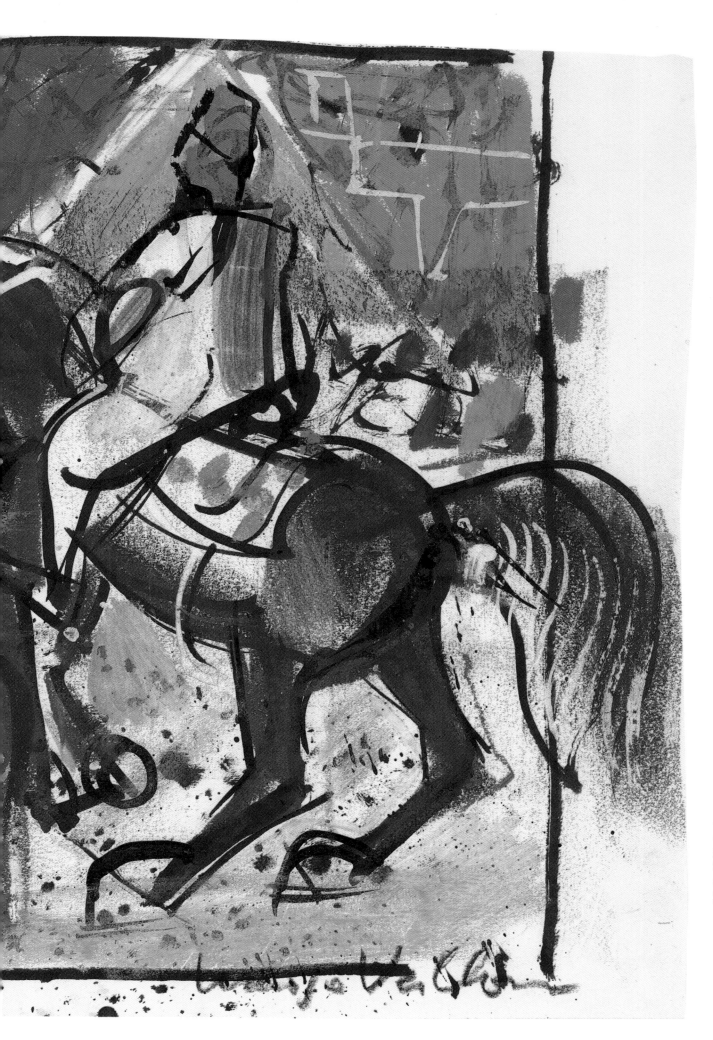

*Festival horses
in the tent*, painting made
from a sketch,
mixed media,
21x30

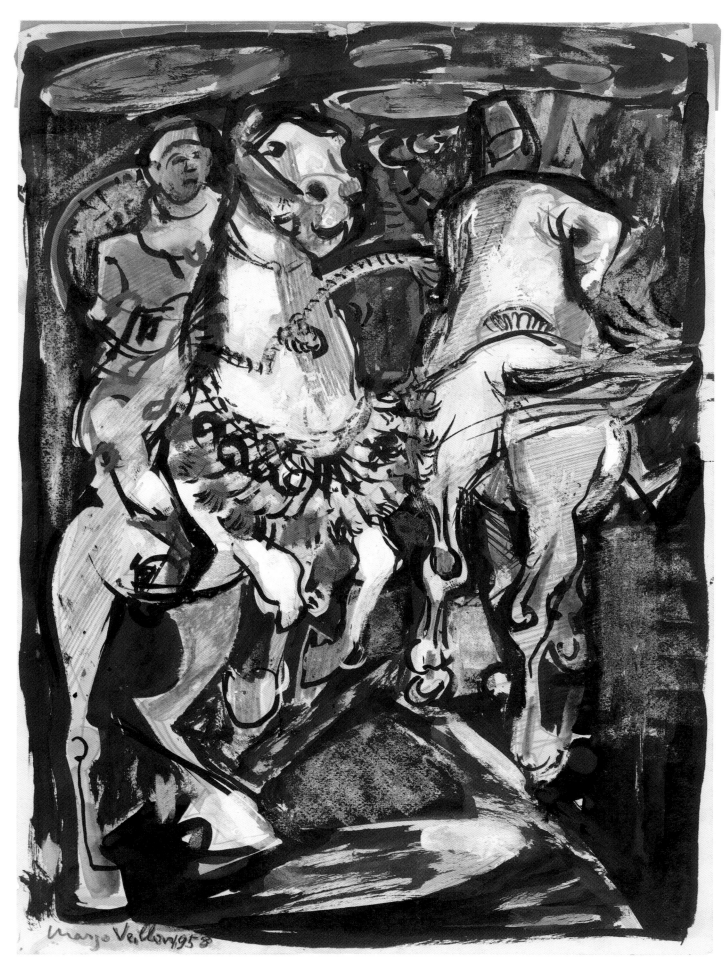

Horse dance, mixed media, 32x23, 1958

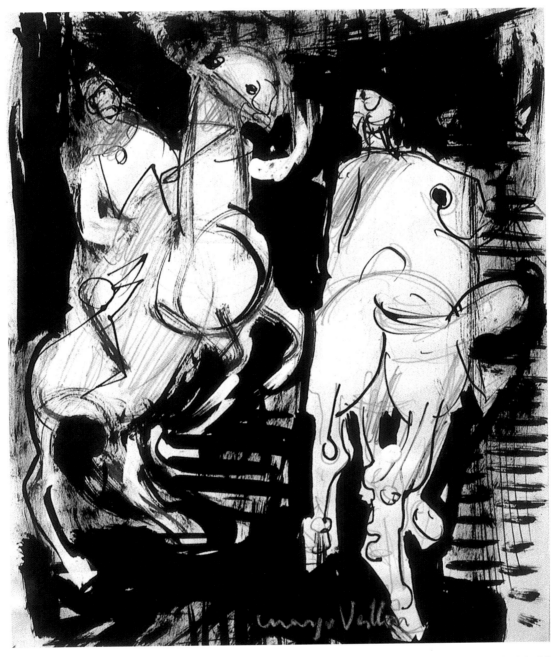

Horse dance, ink, 28x22

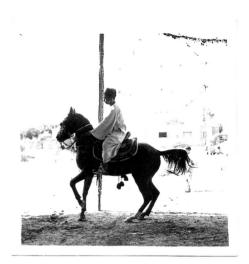

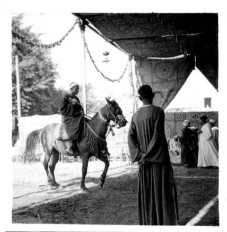 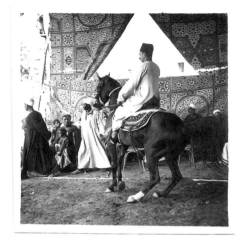 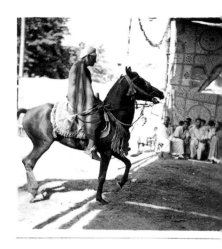

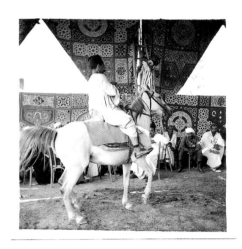 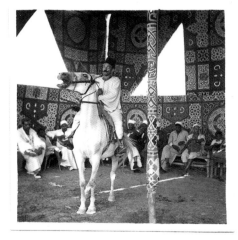 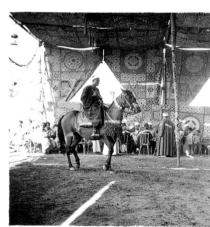

Horses dancing under the festival tent, black-and-white photographs

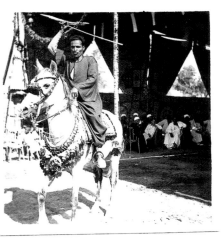

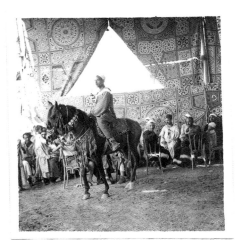

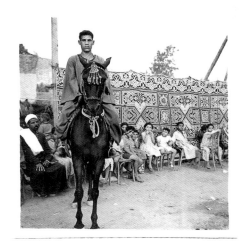

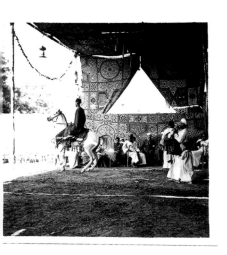

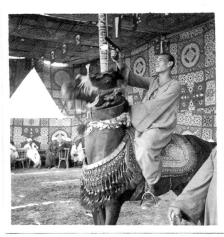

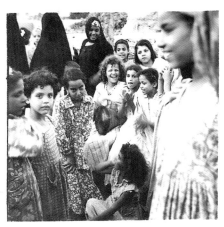

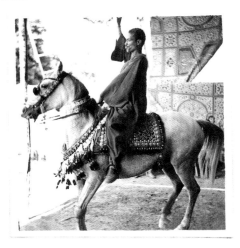

Snapshot of a horse,
ink and gouache, 48x56

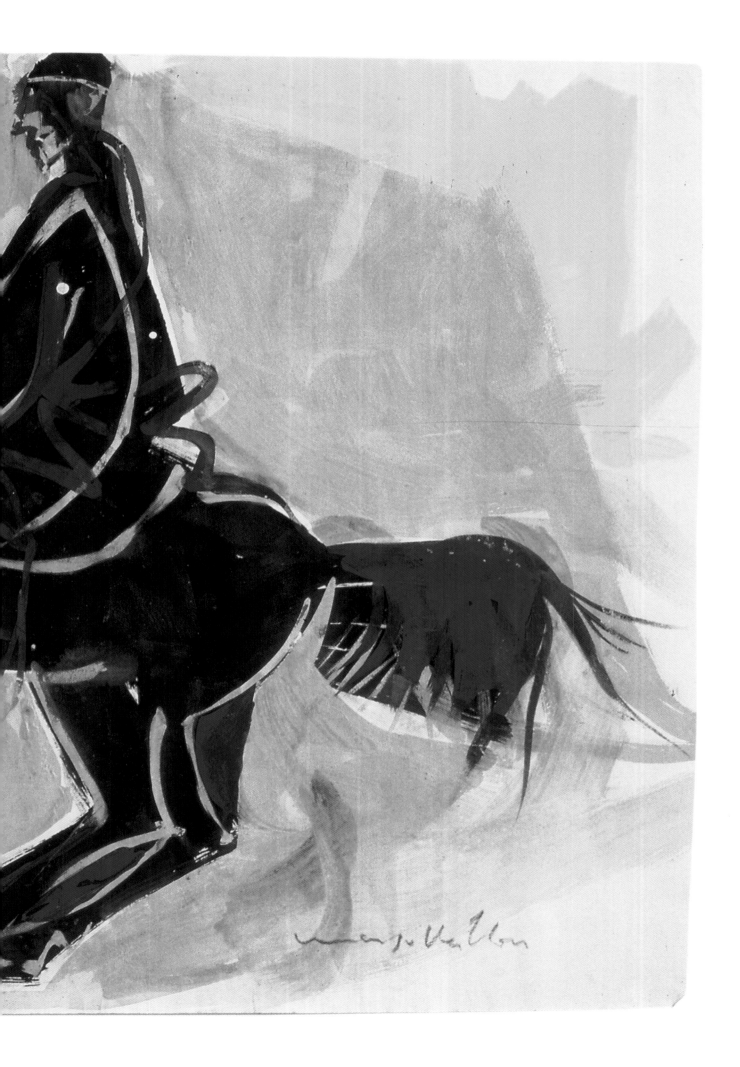

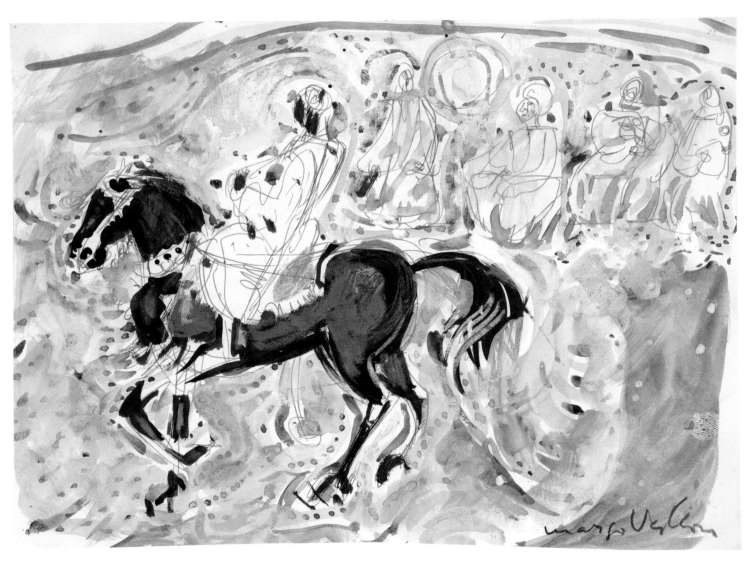

Untitled, watercolor, 23x30

50

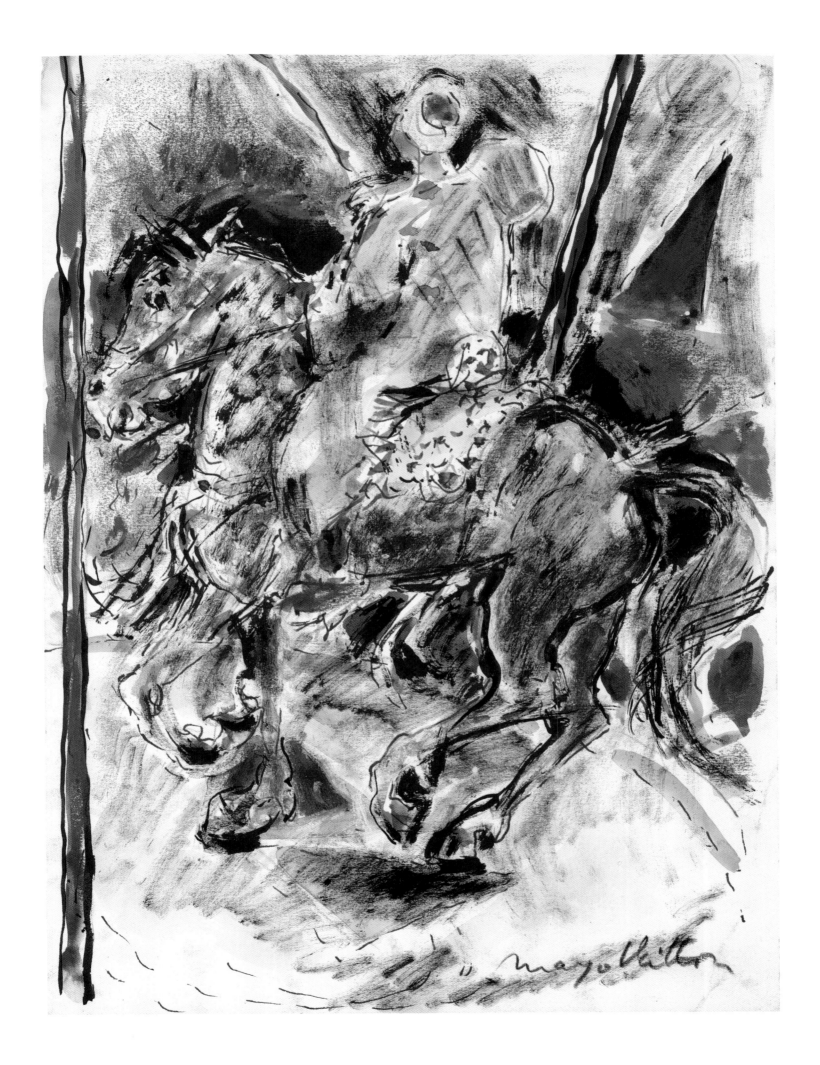

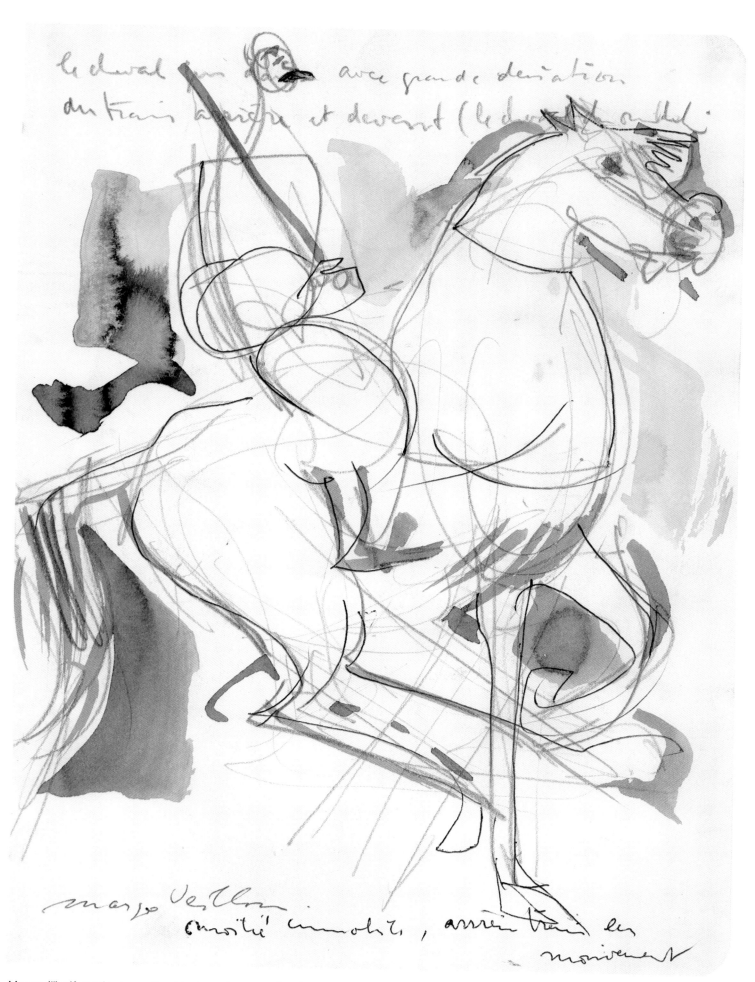

Horse ("half motionless, the hindquarters moving"), ink, 28x20

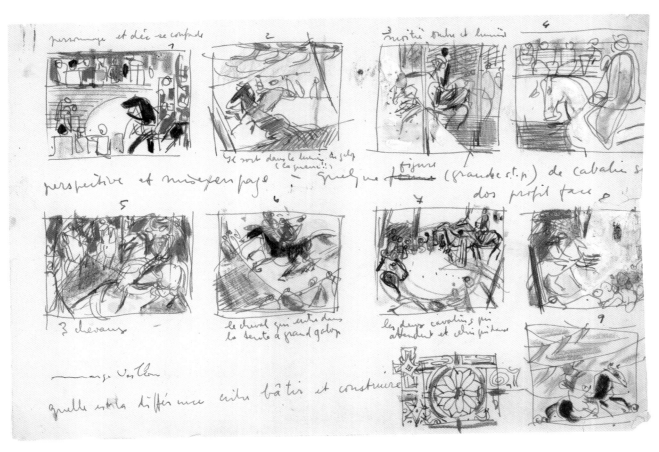

Festival studies ("shade and light, figures and decor blend"),
mixed media, 21x30, 1954

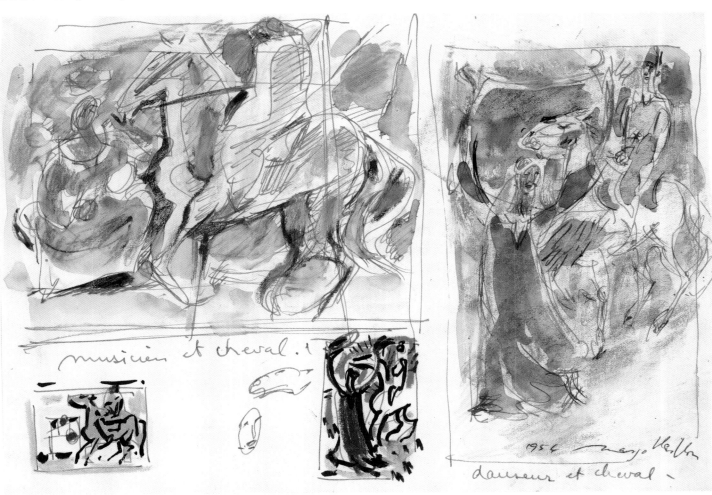

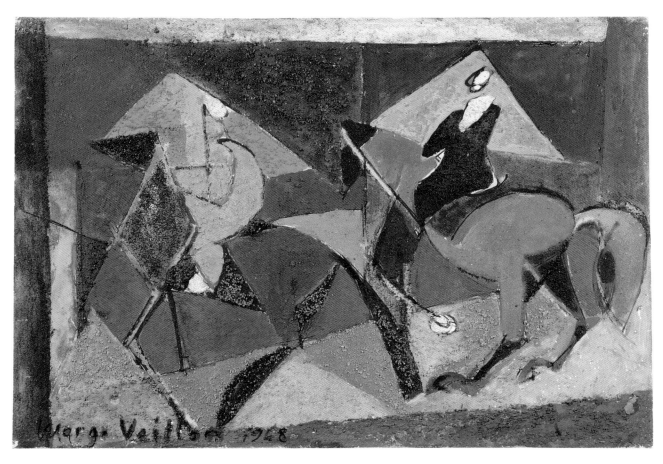

Stylized reworking of a sketch, mixed media, 22x31, 1968

Stylized reworking of the stick dance on horseback, mixed media, 30x21

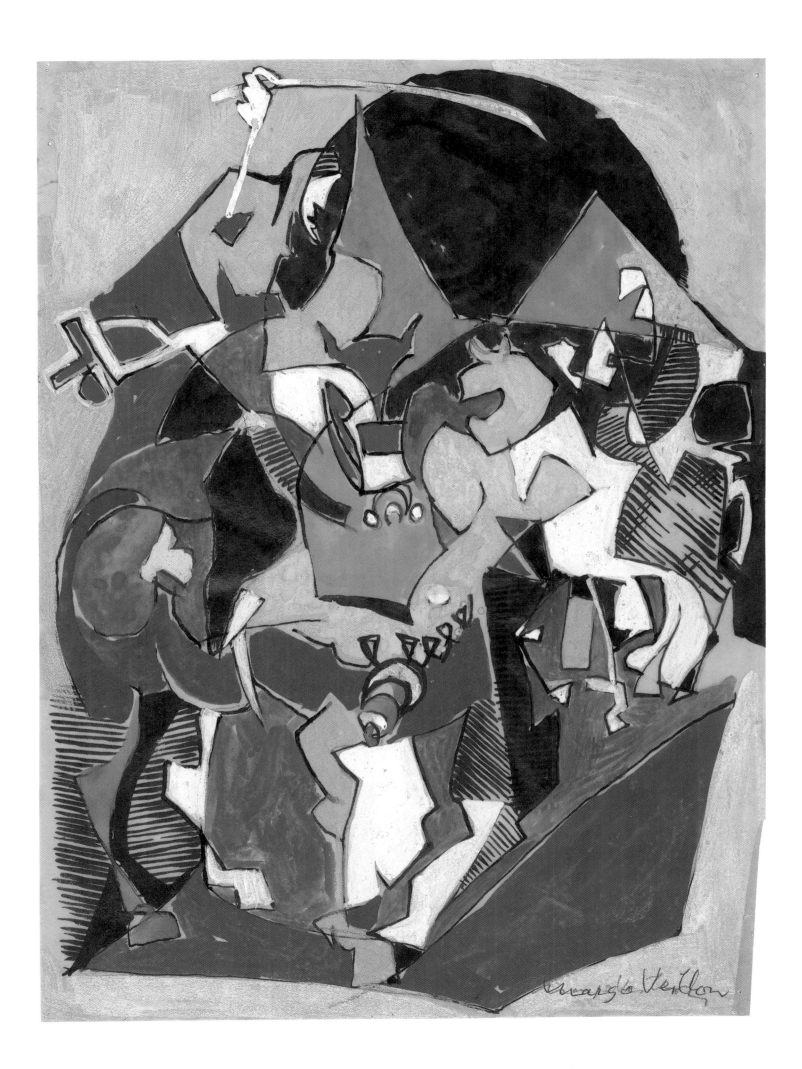

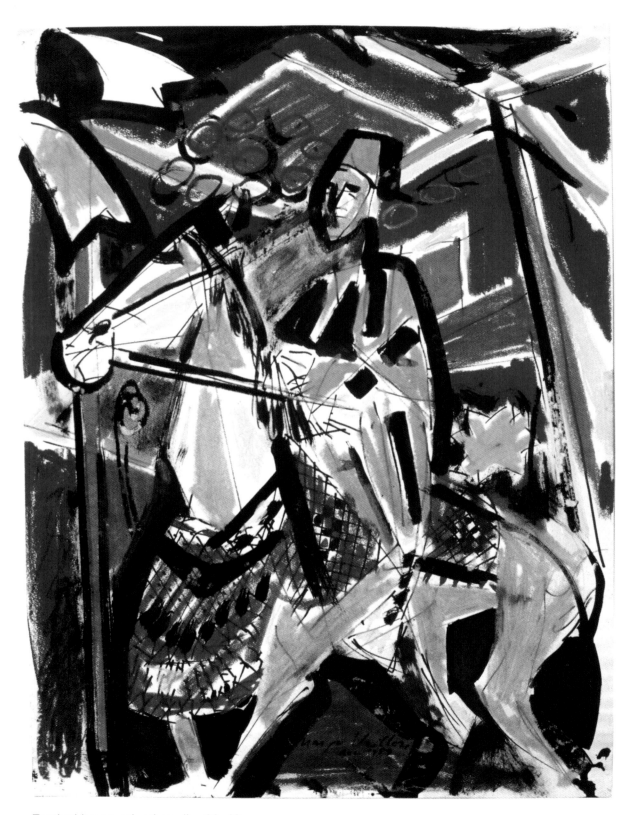

Festival horse, mixed media, 66x49

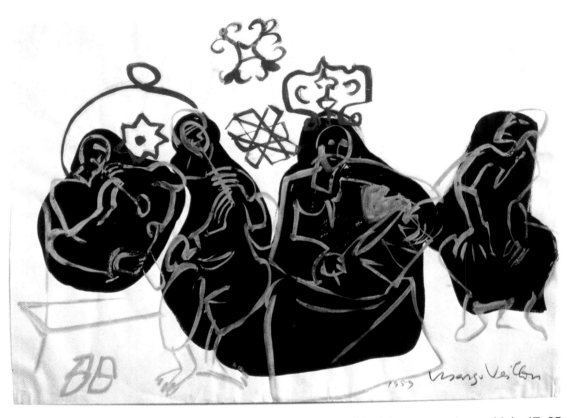

Musicians, gouache and ink, 47x65

Musicians

Musicians are the favored players of the festivals. Good as
gold, they present the artist with infinite variations, great
sweeps of the violin or the *rababa*, the flute-players' crouched
bodies and cheeks about to burst, the serenity of the tam-
bourines and *tablas.*

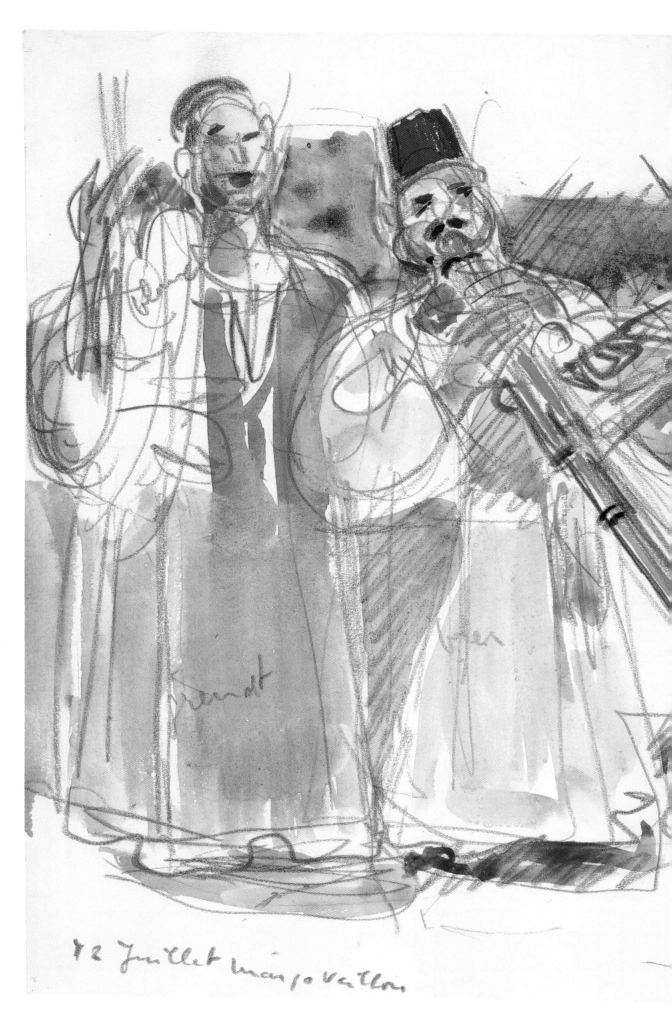

Baladi orchestra ("for the first time, I see the long flute"), watercolor and pencil, 22x31, dated 12 July

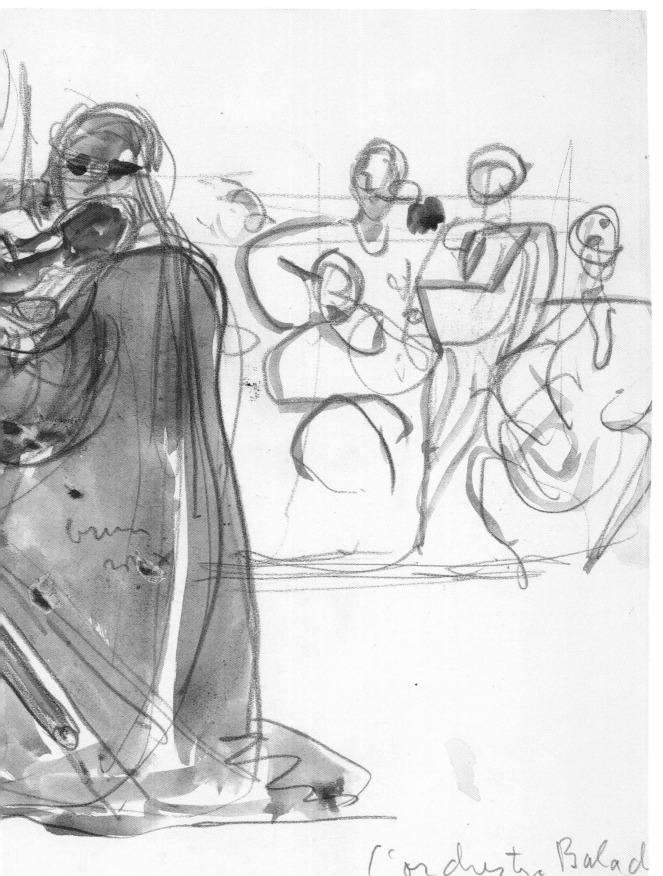

L'orchestre Balad
le chant improvisé
pour la 1ère fois vois la longue flûte

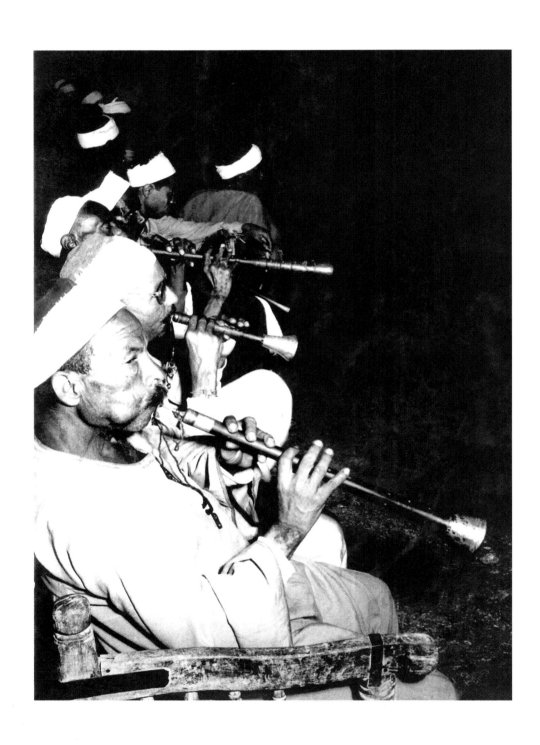

Chorus of flute-players, oil on canvas,
120x70, 1979 (after an undated
black-and-white photograph)

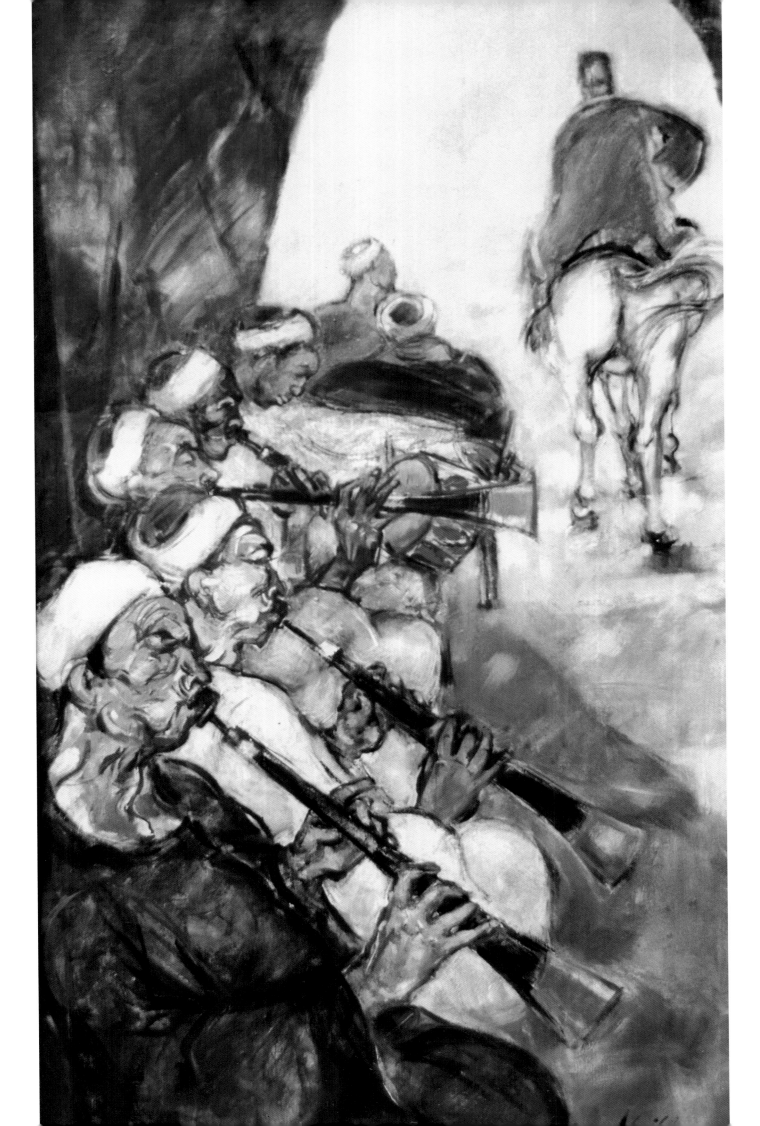

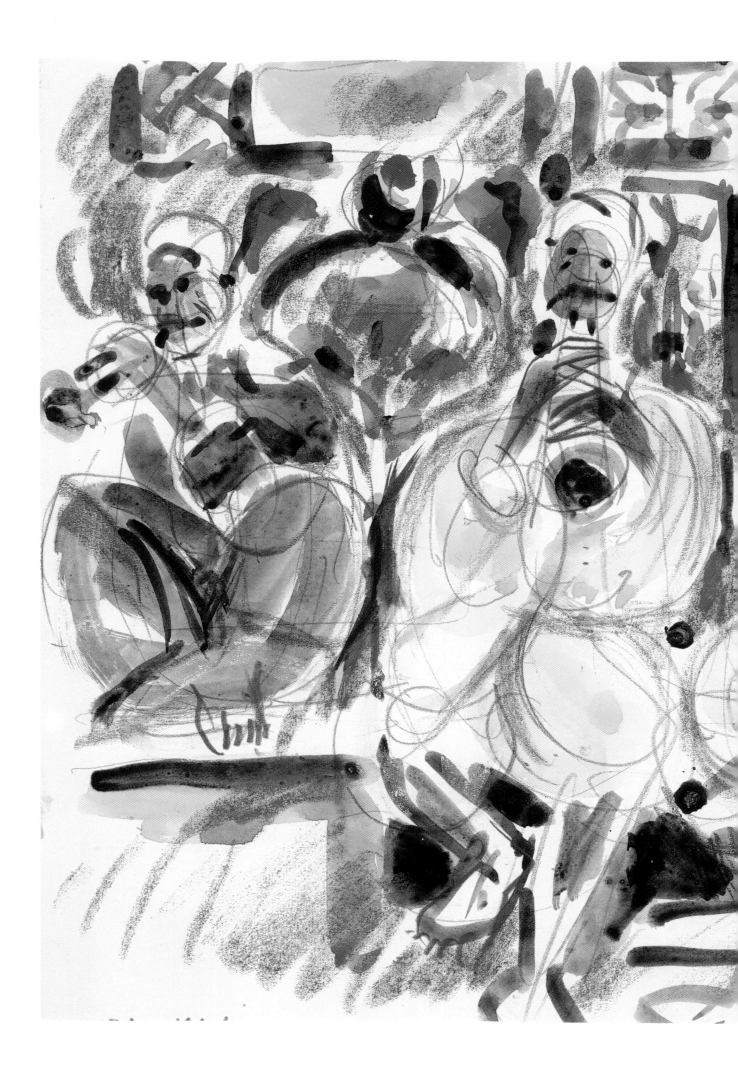

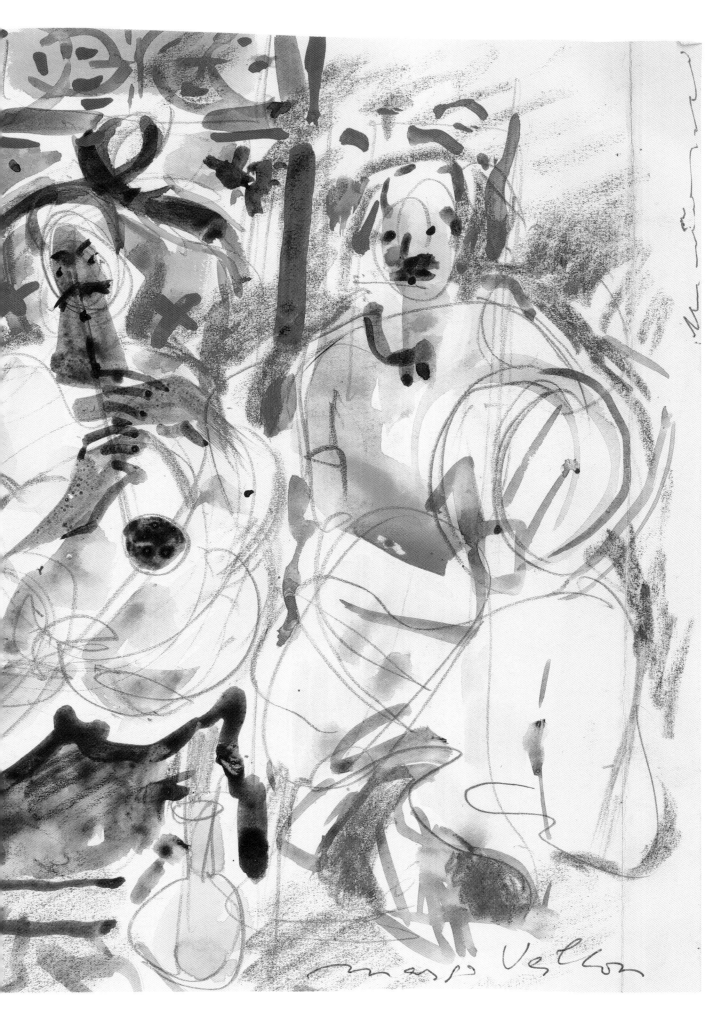

Orchestra,
watercolor,
22x32

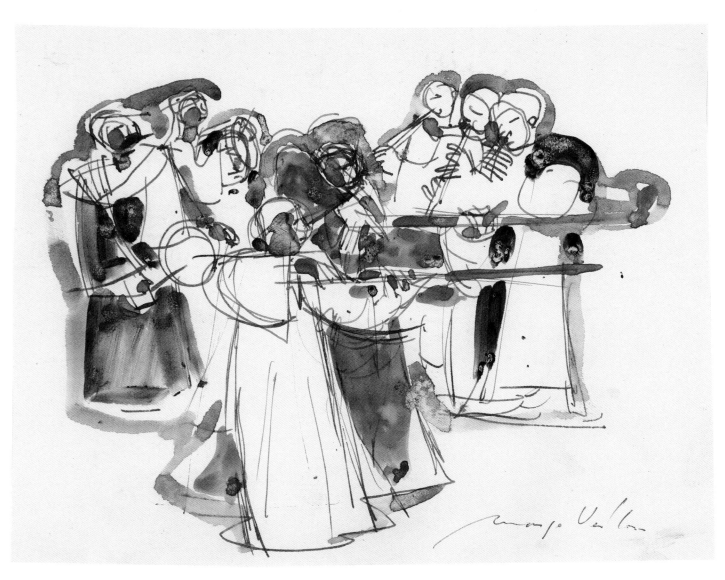

Flute-players, drummers, and the stick dance,
watercolor and pencil, 19x24

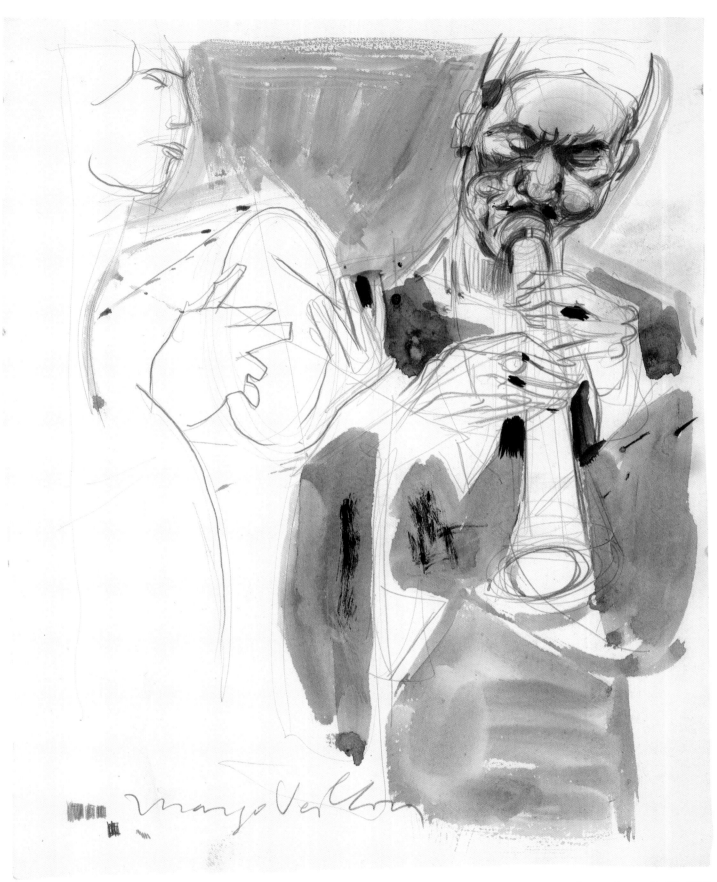

Two musicians, watercolor and pencil, 30x23.5

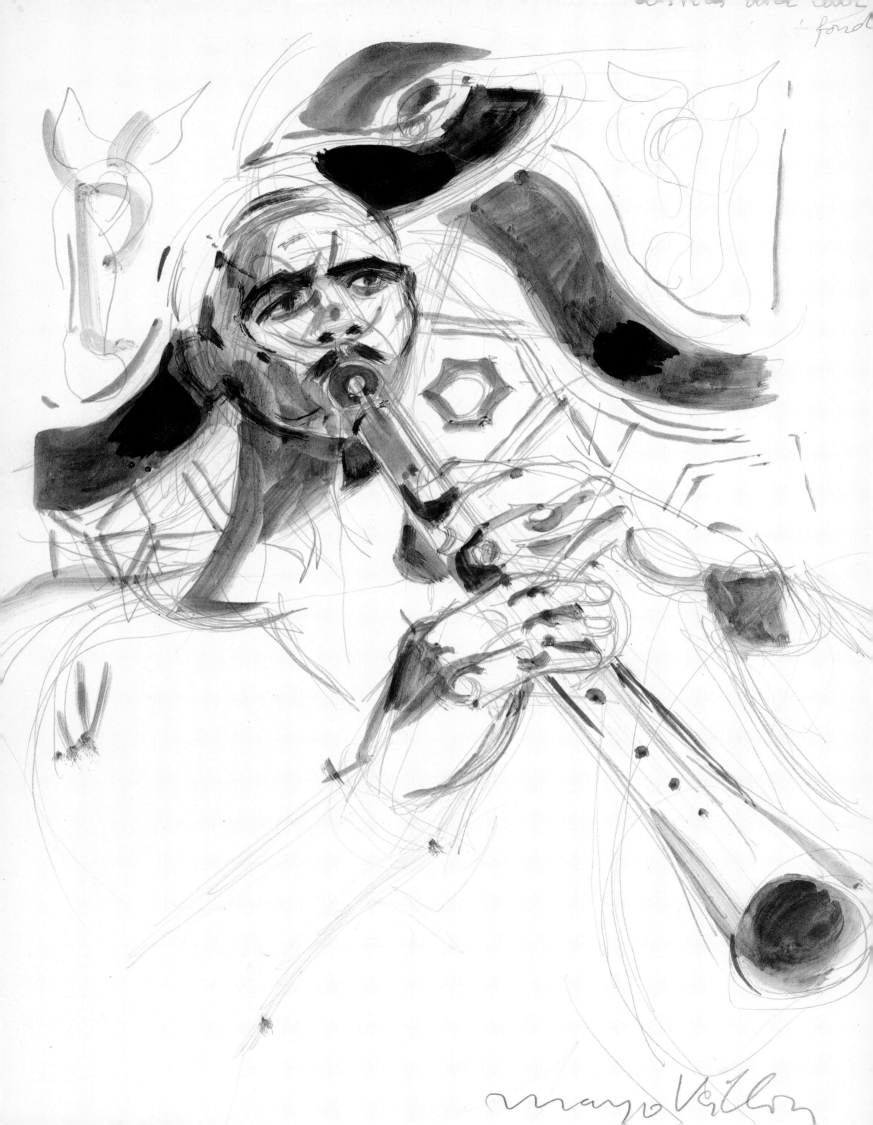

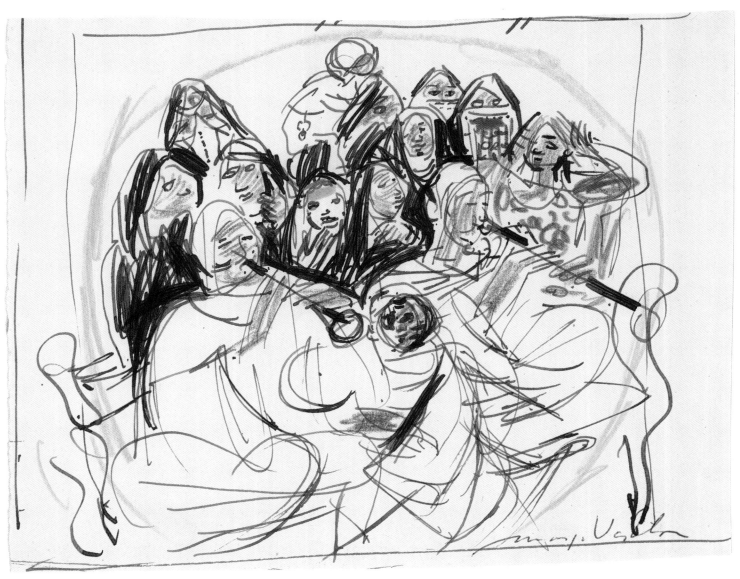

Two flute-players among women spectators,
ink and watercolor, 21x46

Flute-player, watercolor
and pencil, 30x22

67

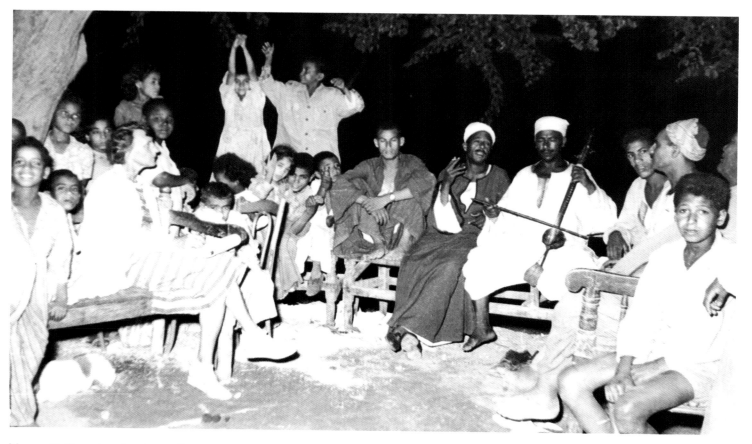

Margo Veillon drawing in a village

Rababa-player,
watercolor
and ink, 30x23

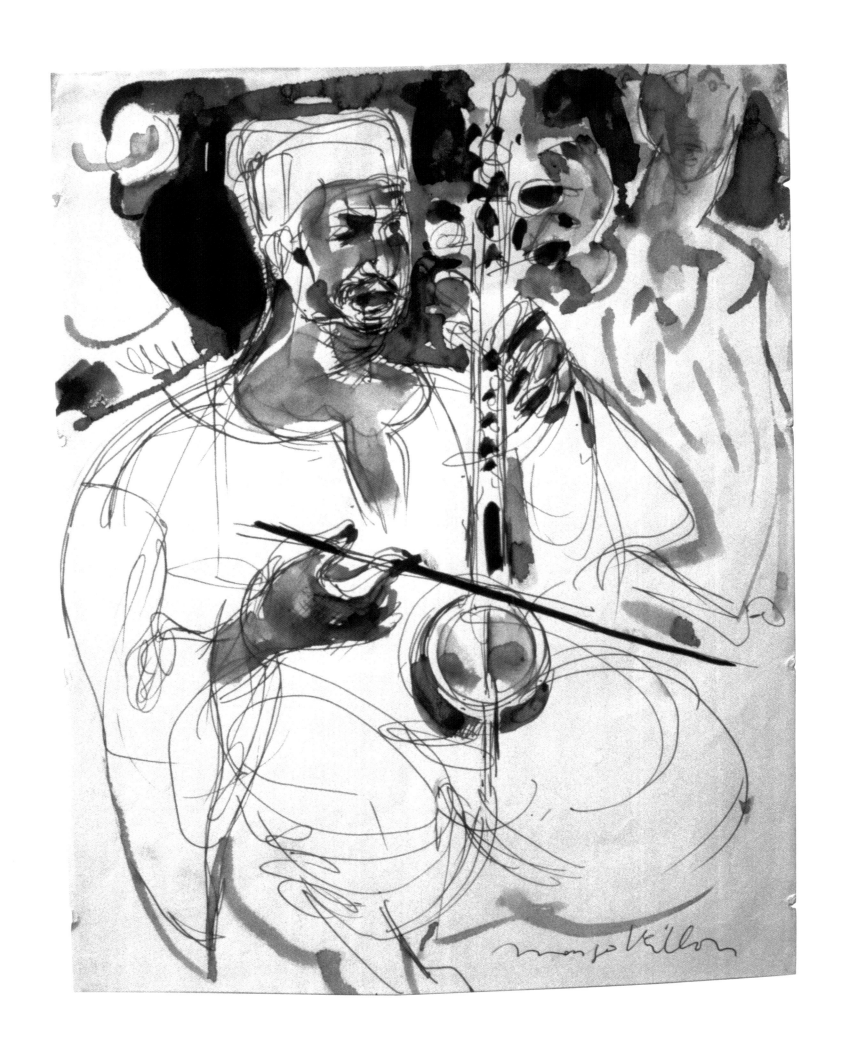

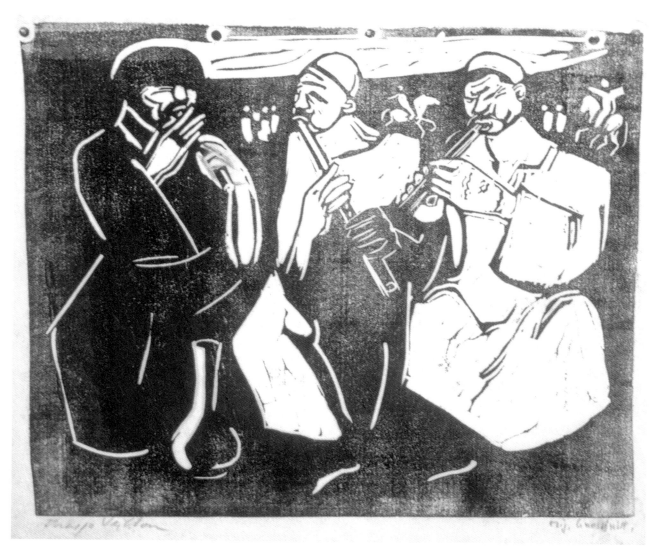

Three flute-players, lino cut

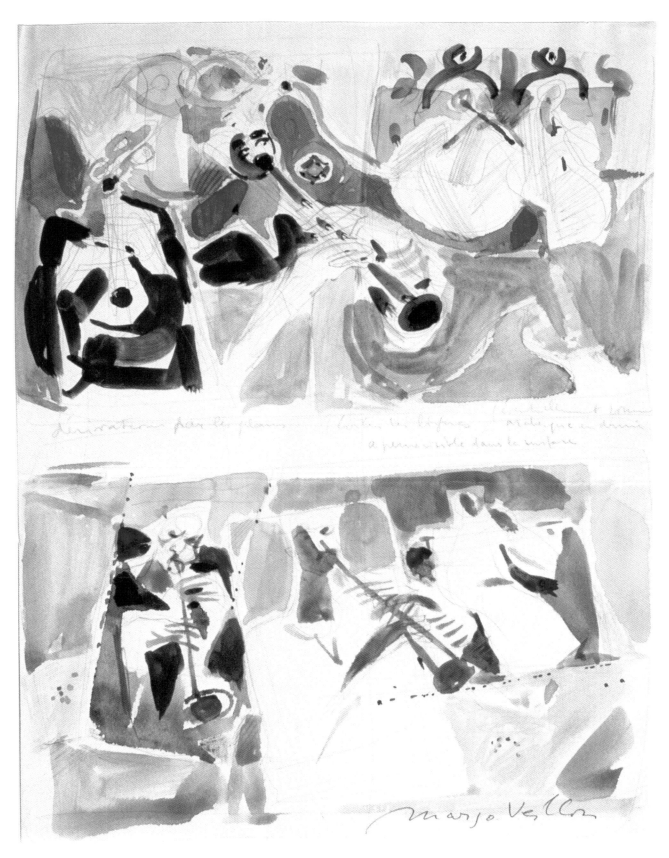

Musicians ("derivation from planes / avoid lines / eventually form arabesque
at the end just visible on the surface"), watercolor and pencil, 27x20

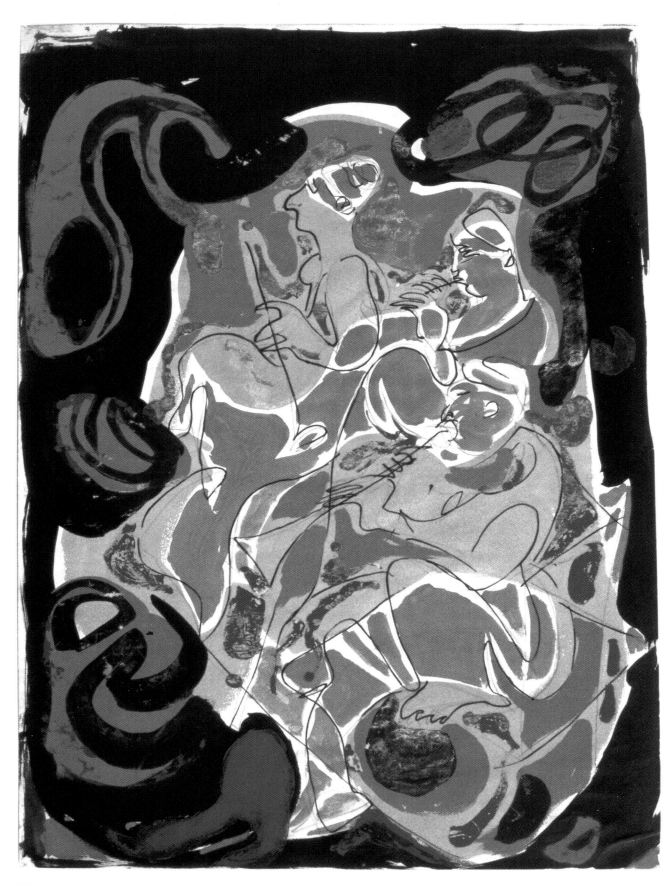

Three musicians, mixed media, 67x49

Mourning, detail

Mourning

Hands slapping faces, bracelets broken, endless cries—on the day of a death, mourners tear themselves apart. Then, at regular intervals, they come back to the tombs to honor those no longer here, a gesture from ancient times described with blues and reds so deep.

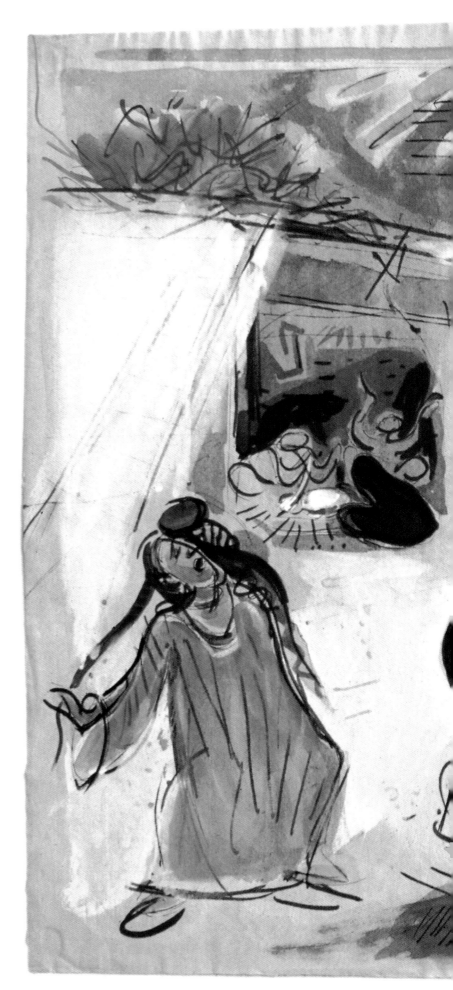

Mourning in a house,
watercolor and ink,
48x63, 1945

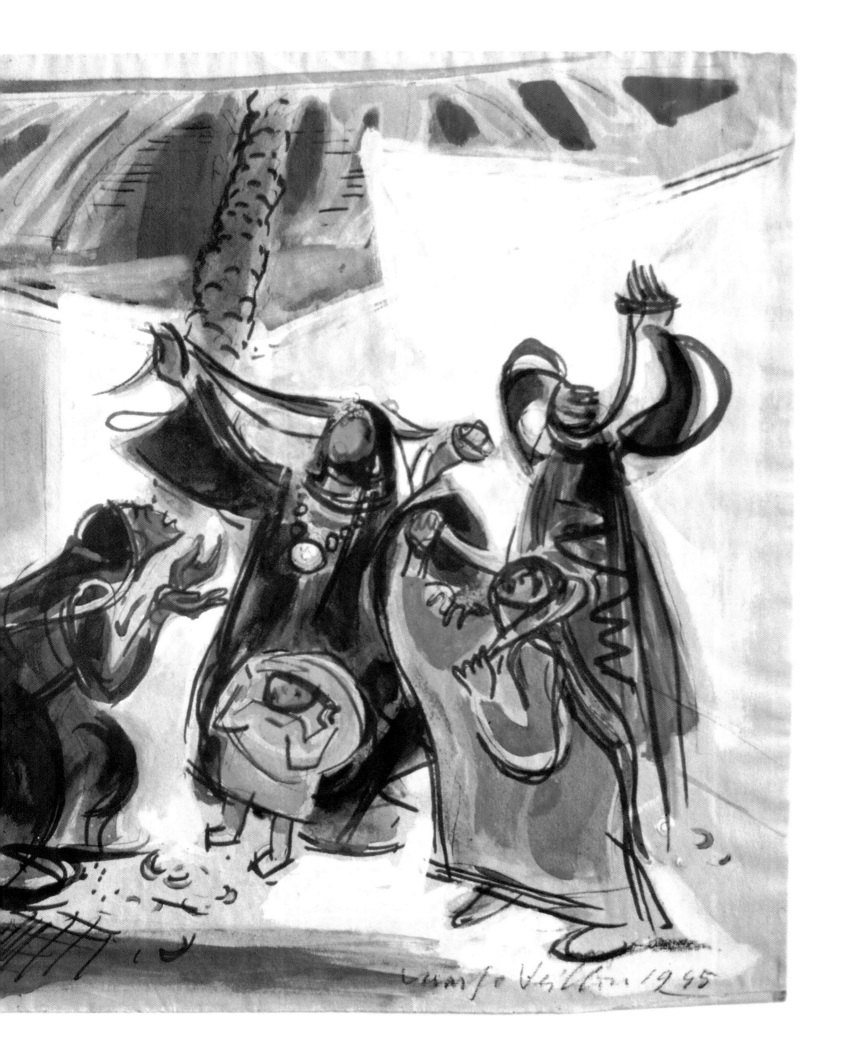

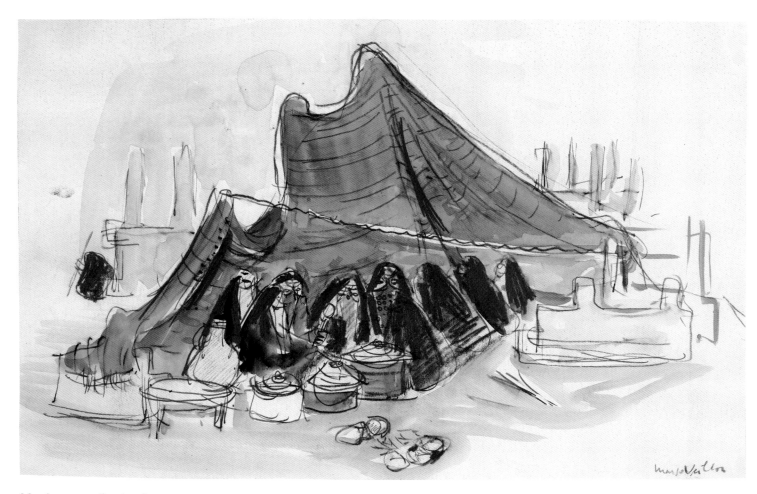

Meal among the tombs,
watercolor and ink, 29x44

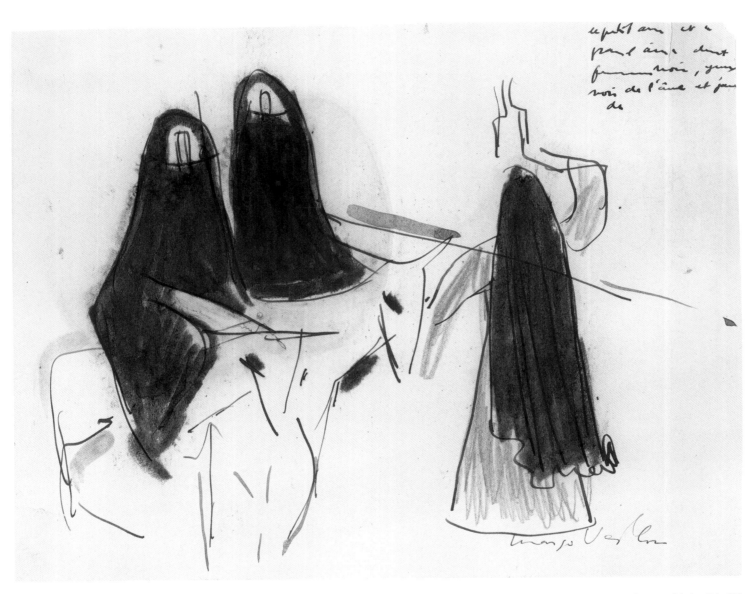

On the road to the cemetery, watercolor and ink, 21x27

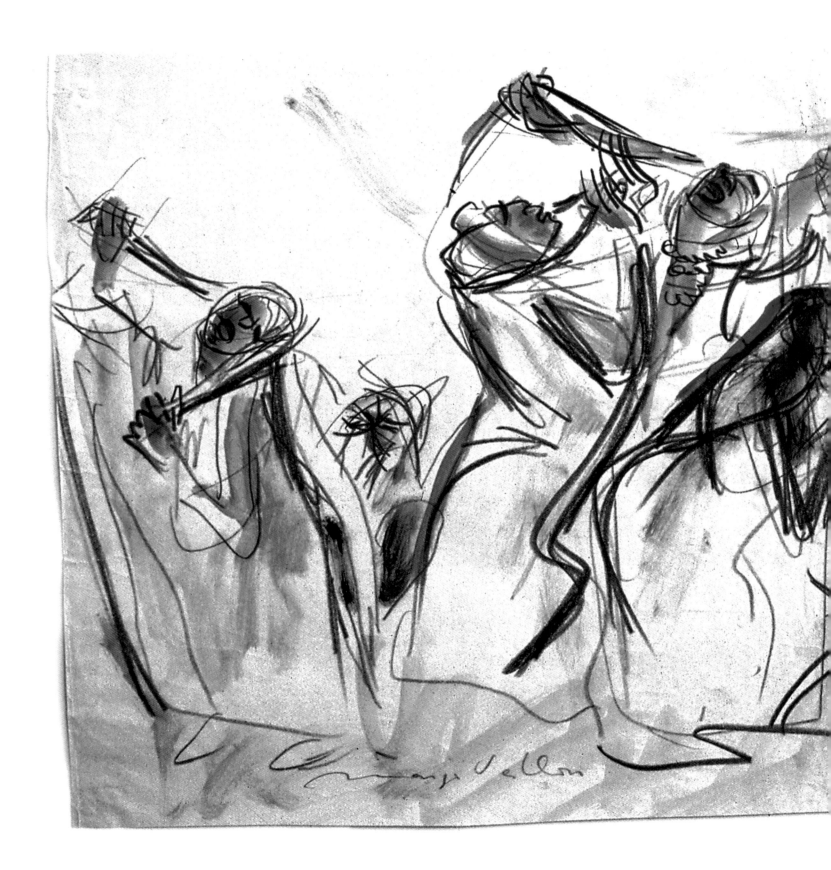

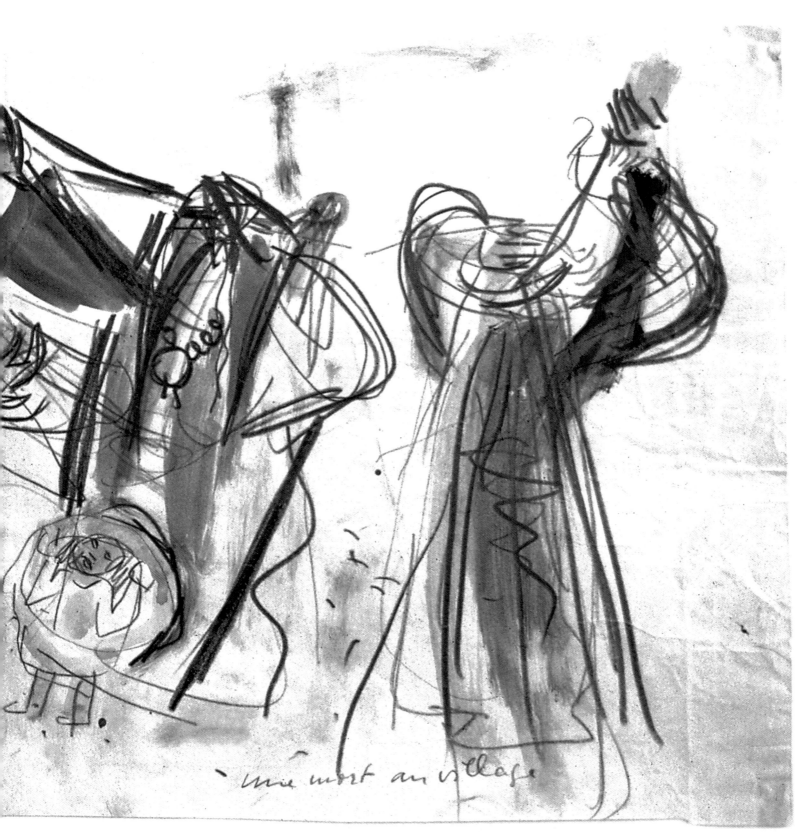

A death in the village, watercolor and ink, 32x64

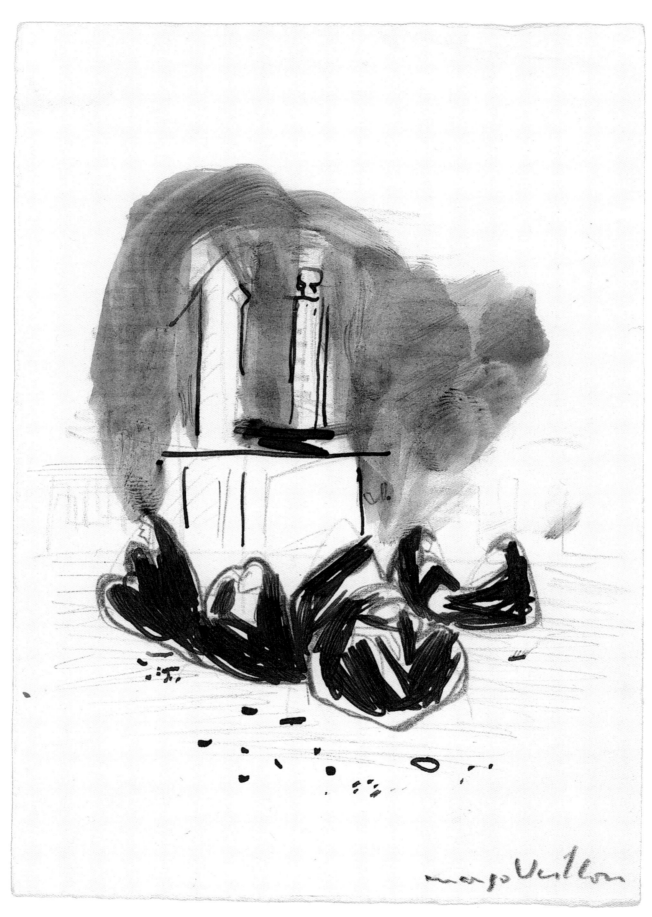

Visit to the cemetery, ink, 14x10

Shamm al-Nesim, detail

Shamm al-Nesim

Shamm al-Nesim, literally 'smelling the breeze.' It is the festival of
spring, and thus of flowers; the time to go outdoors and spill out along
the banks of the river.

Next page: Shamm al-Nesim, watercolor and pencil, 30x43

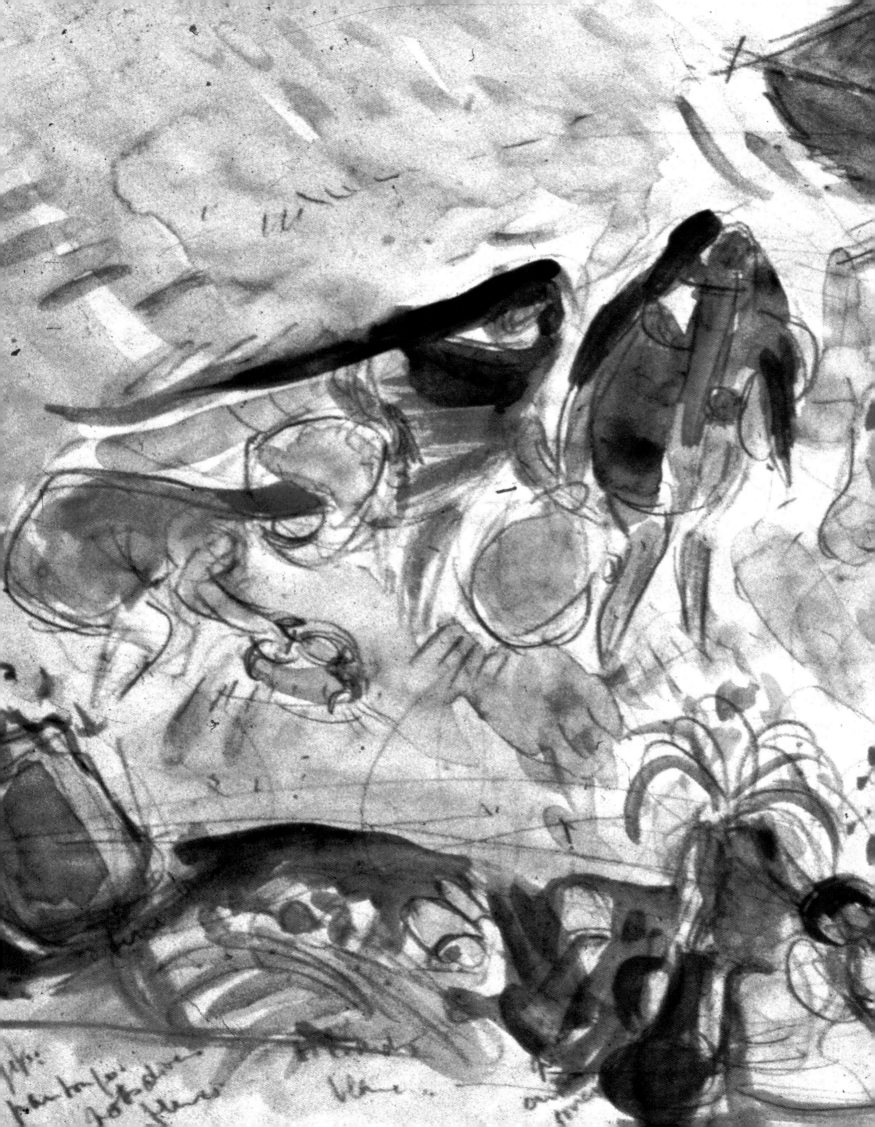

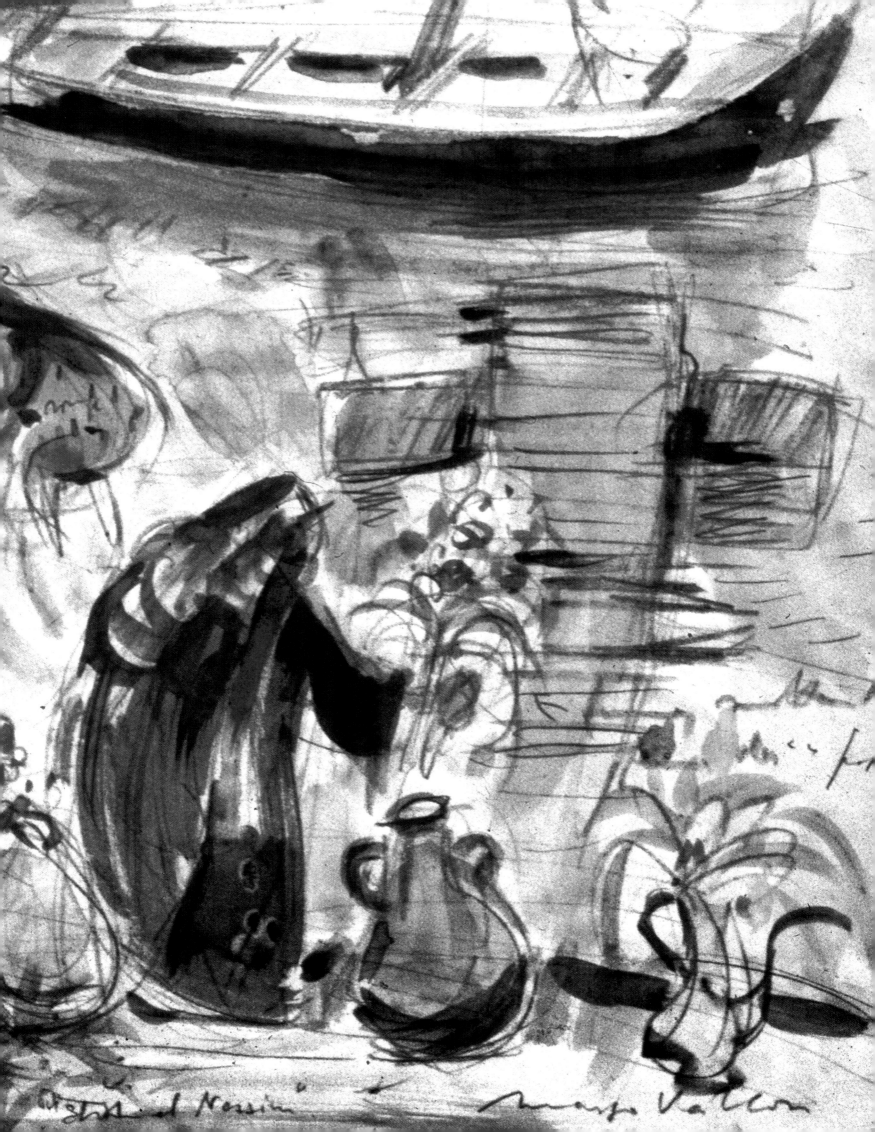

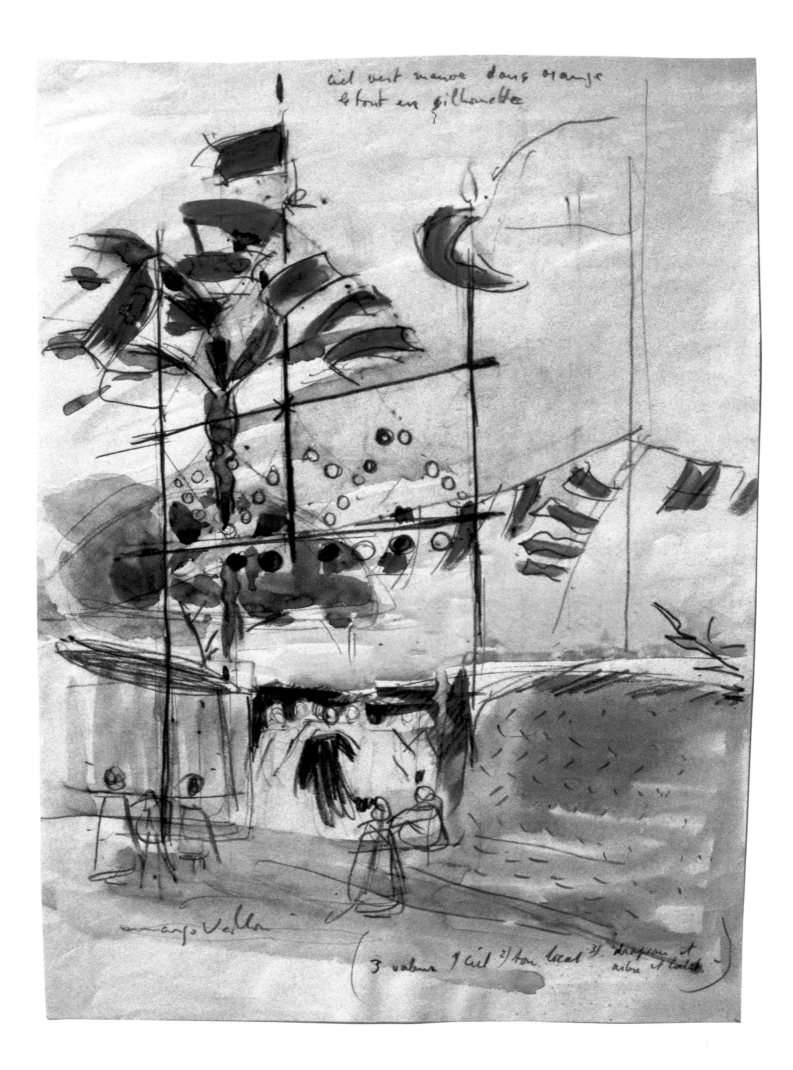

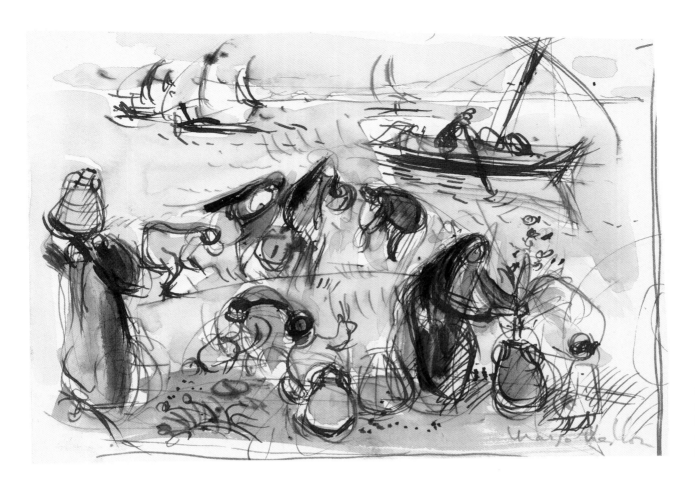

*Gathering flowers
on the banks of
the Nile for
Shamm al-Nesim*,
watercolor, 31x43

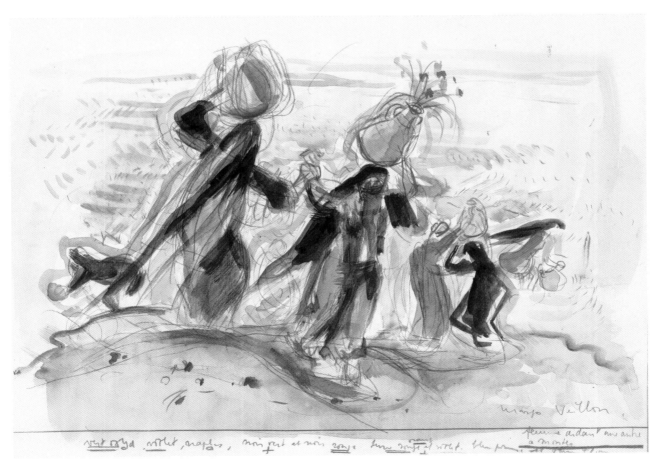

*Gathering flowers
on the banks of
the Nile for
Shamm al-Nesim*,
watercolor, 31x43

Mulid, watercolor and ink, 42x29

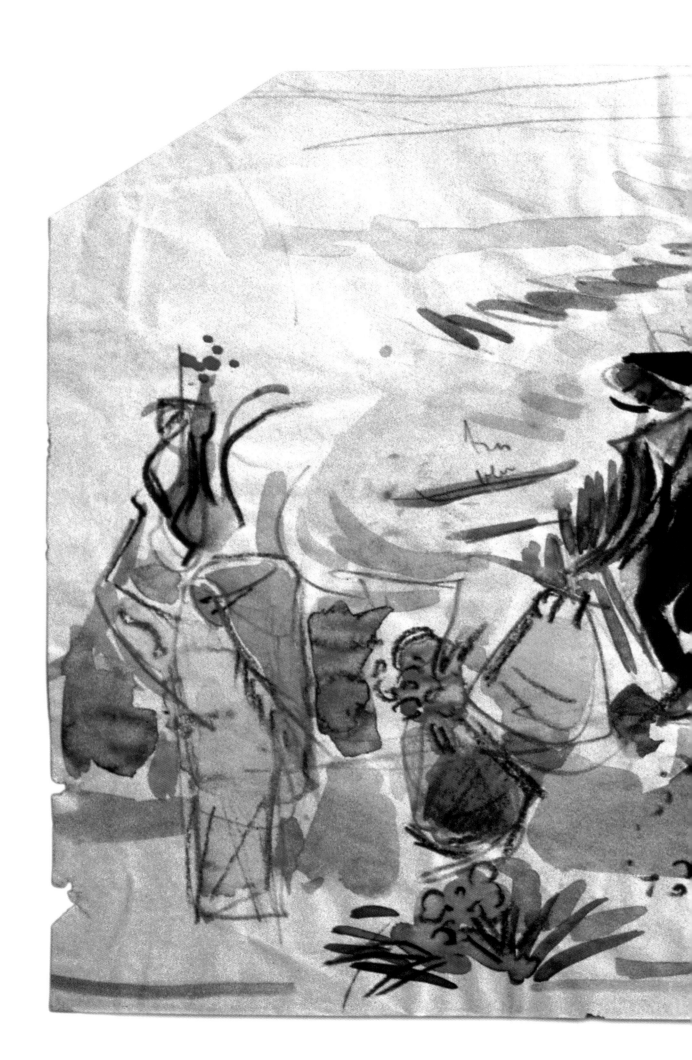

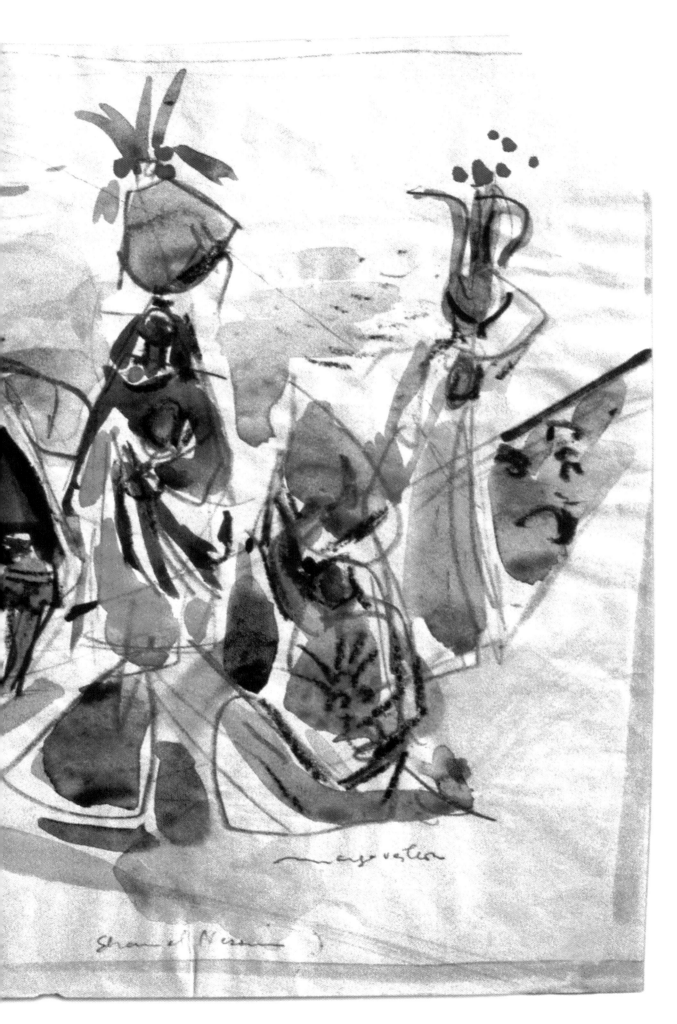

Shamm al-Nesim on the banks of the Nile, watercolor and ink, 25x34

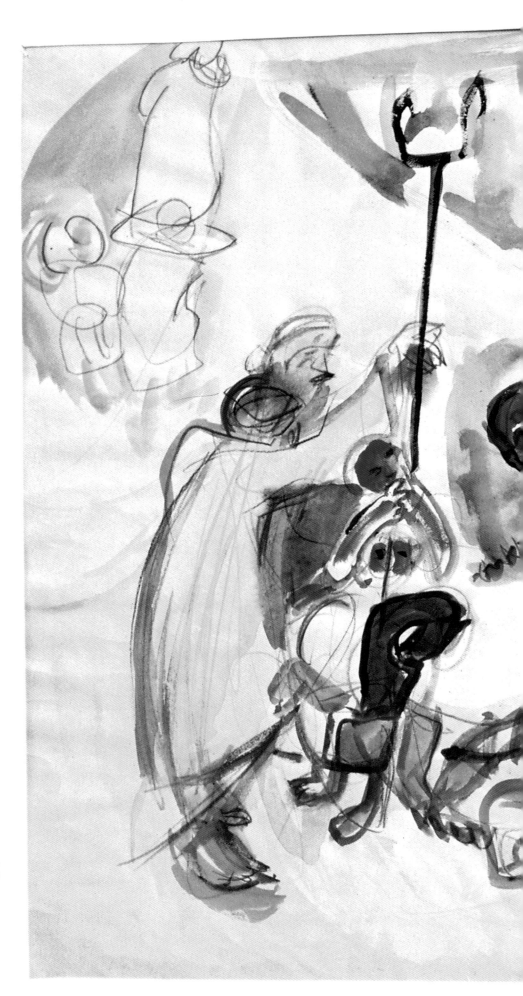

Fairground attraction,
watercolor and ink, 46x58

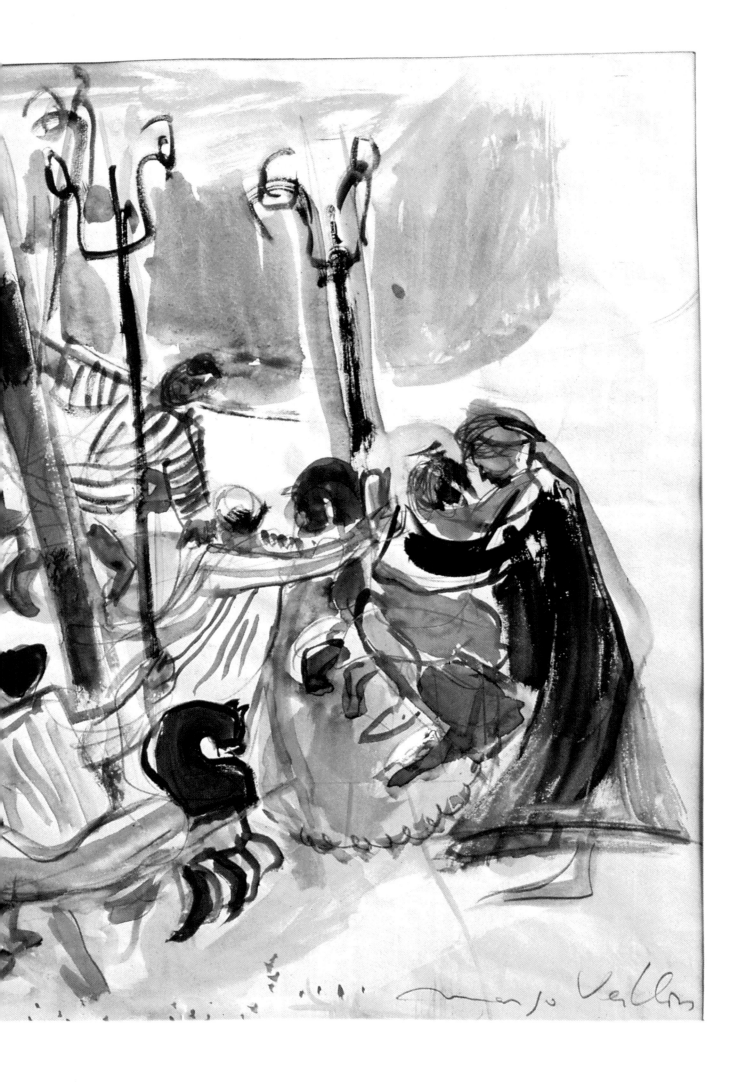

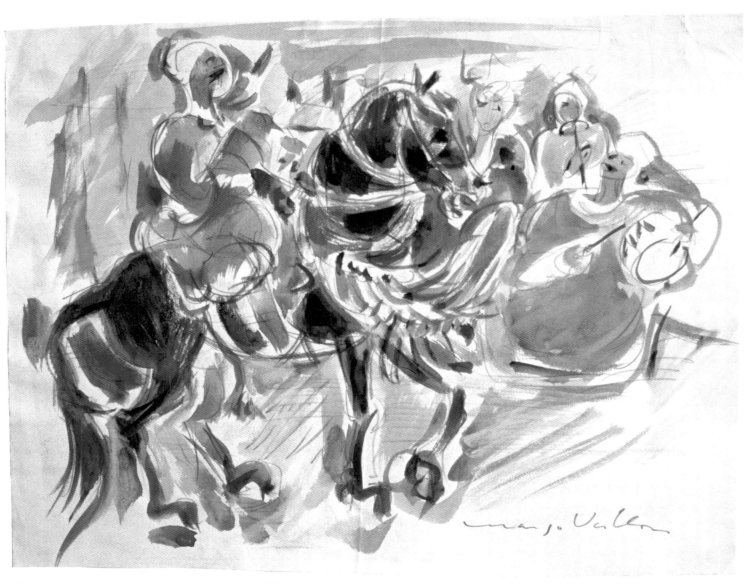

Dancing horse and musicians, watercolor, 27x34

Fairground attraction, detail

The Merry-Go-Round

The merry-go-round is the symbol of the festival. The world turns; the festivals remain, the eternal ride to take one away from the everyday. The merry-go-round is the symbol of the children who can go around and around without ever tiring. The festival and children: two friends who love each other equally—and more and more with each ride.

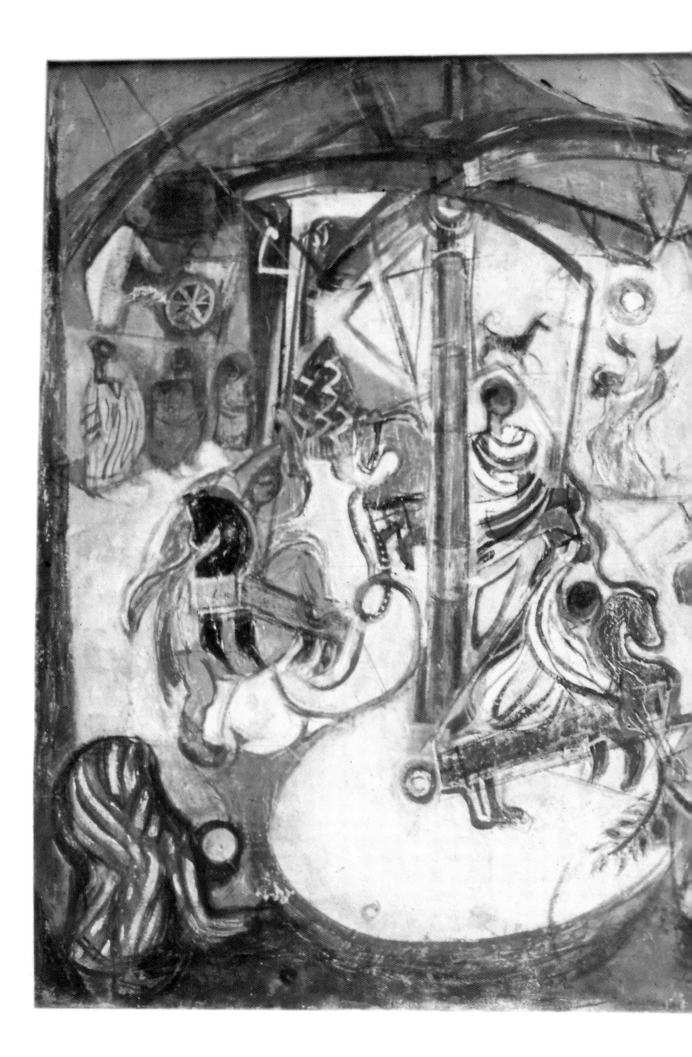

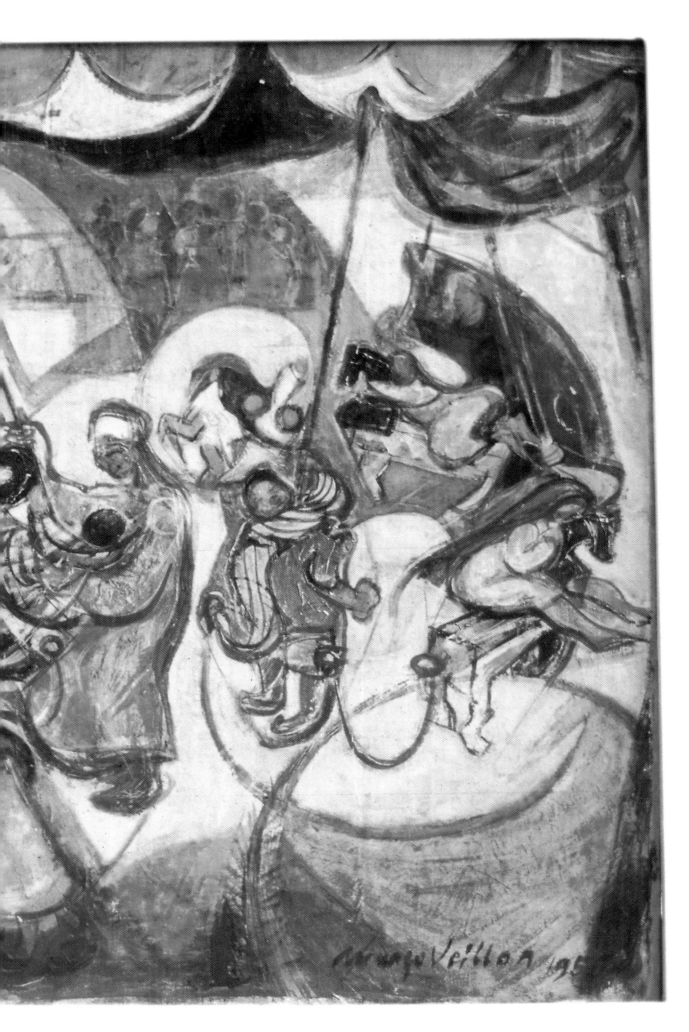

Merry-go-round,
oil on canvas,
80x112, 1955

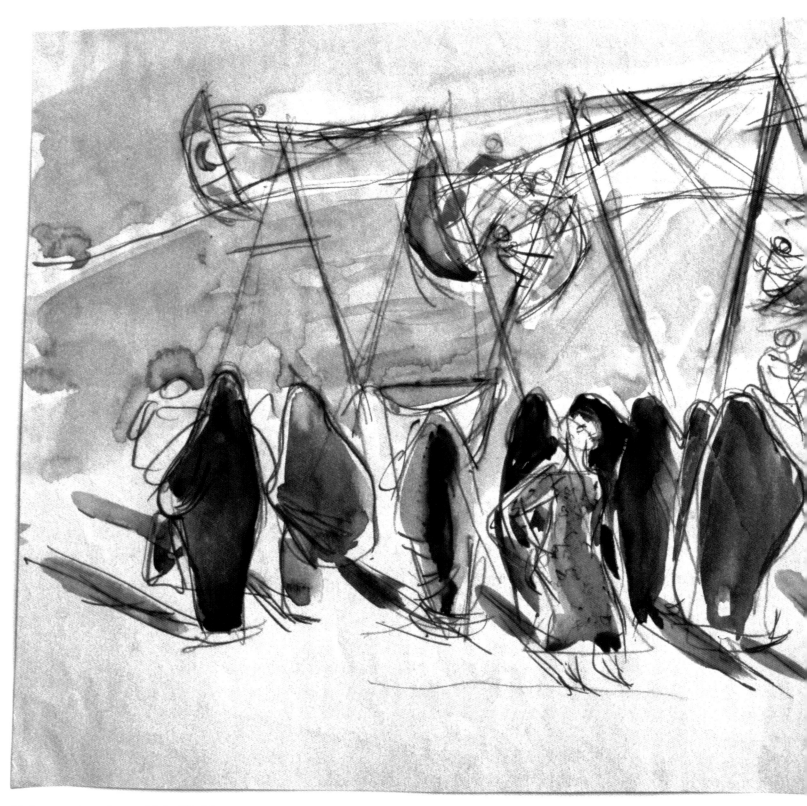

Swings, watercolor and ink, 29x39

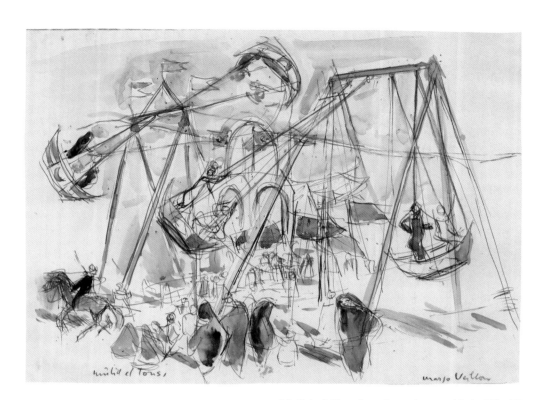

Mulid al-Tunsi, watercolor and ink, 32x43

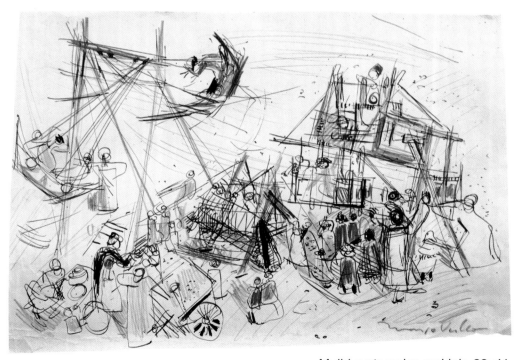

Mulid, watercolor and ink, 29x41

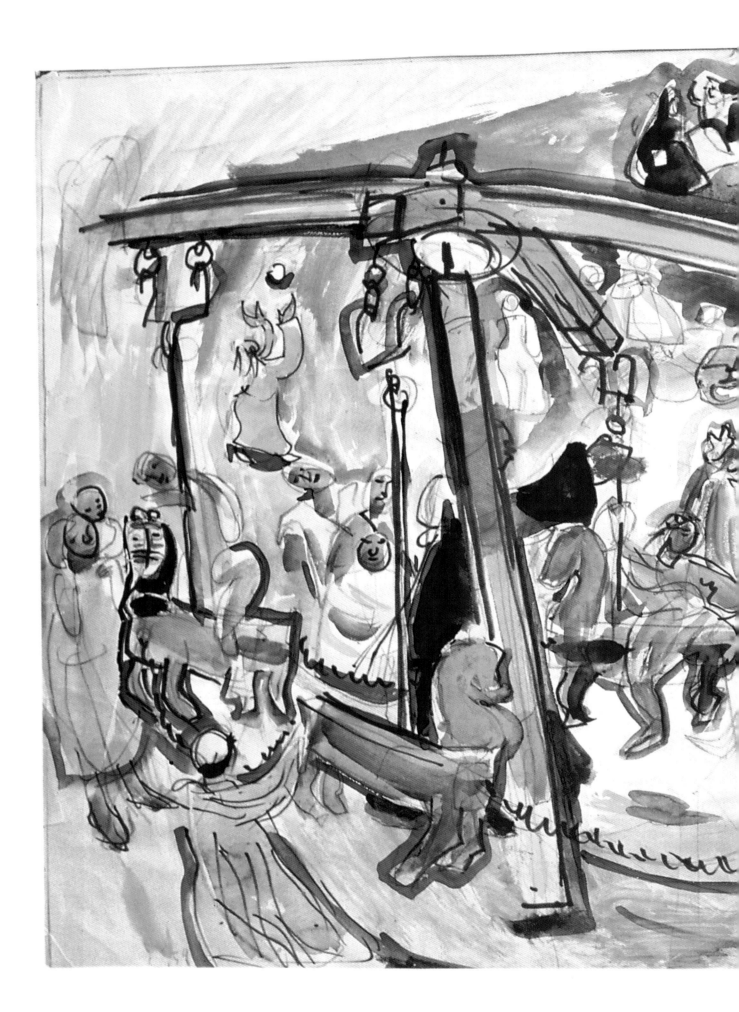

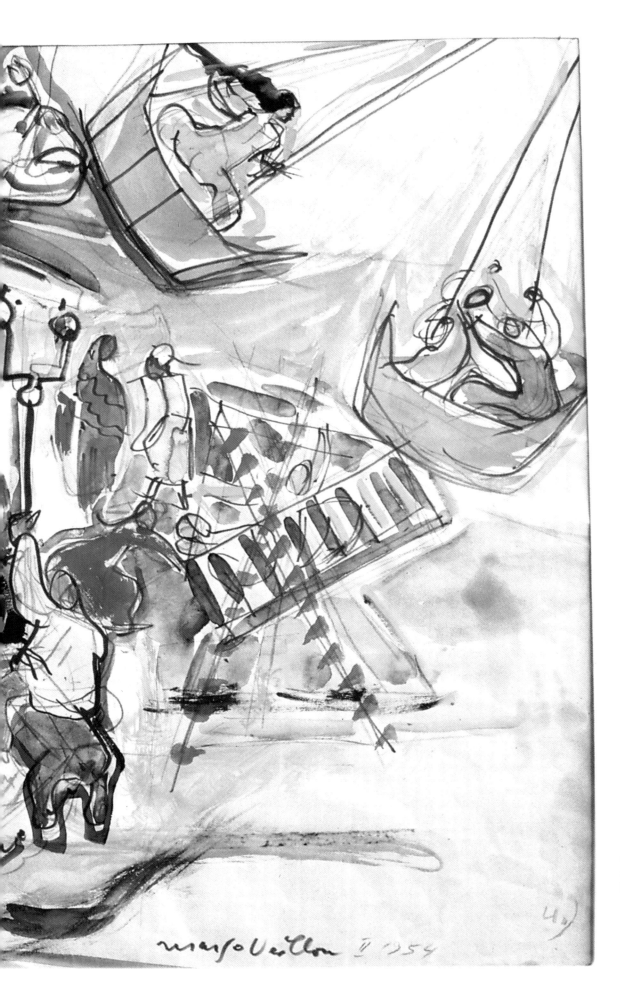

Merry-go-round and swings, watercolor and ink, 47x66, 1954

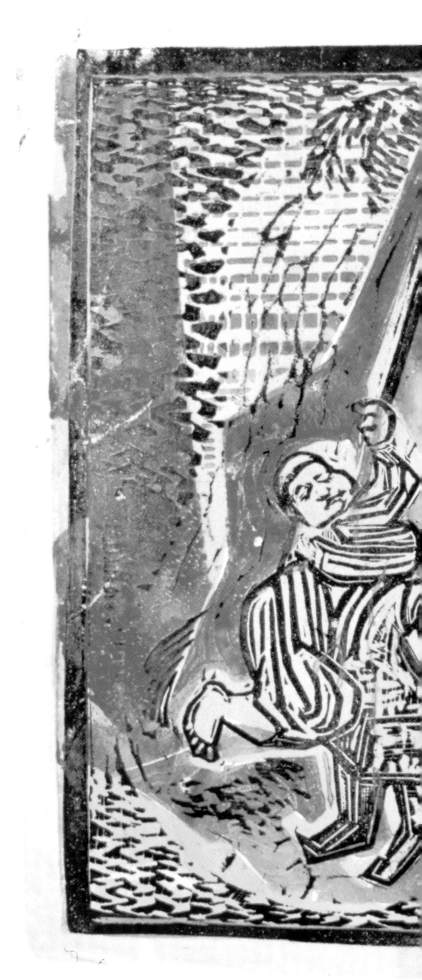

Fairground attraction,
lino cut, 40x50

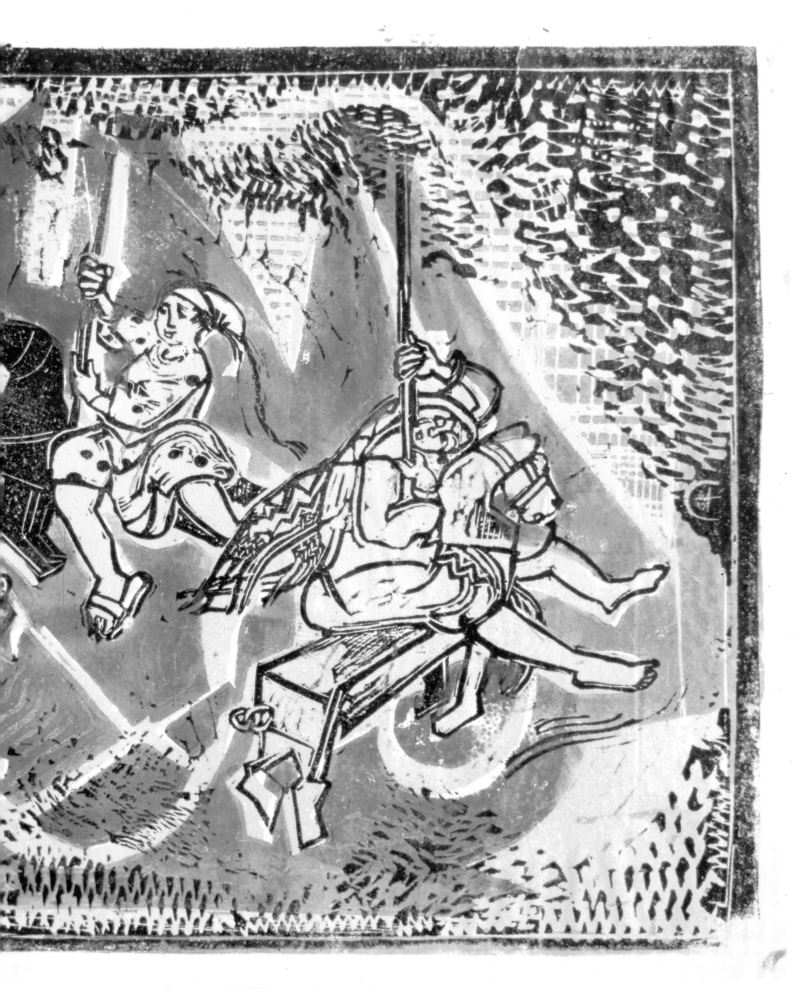

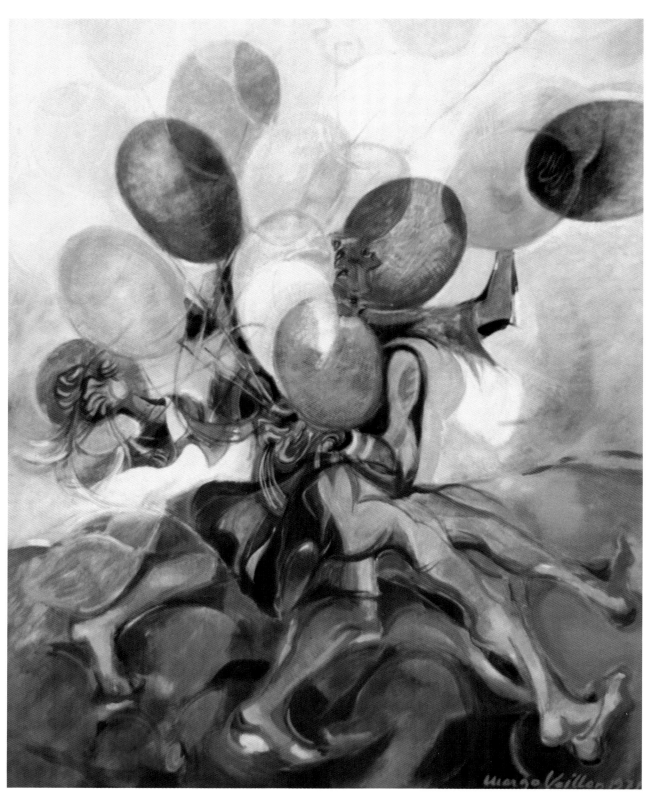

The balloon seller, oil on canvas, 130x90, 1971

Bibliography

Divertimenti. Moutier: Littéraire Romande, 1966. A collection of 60 drawings with a text by V. Bajocchi; 35 de luxe copies with original engravings; English and French editions.

La vie autour des charettes. Lausanne: Serge Dulac, 1974. 16 drawings; text in French by S. Acatos; limited edition of 20 copies.

Margo Veillon Diary. Cairo: The American University in Cairo Press, 1985. Permanent engagement diary illustrated with 50 drawings.

Harvest. Cairo: The American University in Cairo Press, 1985. 16 black-and-white photographs; text in English by John Rodenbeck.

Margo Veillon: Une vie, une oeuvre, une passion. Beirut: Claude Leman, 1987. Text in French; 168 pages.

Nubia: Sketches, Notes and Photographs. London: Scorpion Publishing, 1994. Text in English; 168 pages.

Margo Veillon: Le mouvement éclaté / The Bursting Movement: Travaux, 1925–96. Cairo: The American University in Cairo Press; and Lausanne: Acatos, 1996. Edited by Charlotte Hug; 264 pages.

Margo Veillon Diary. Cairo: The American University in Cairo Press, 1996. New permanent engagement diary illustrated with 50 drawings.

Egyptian Harvests. Cairo: The American University in Cairo Press, 2000. Text in French and English by Charlotte Hug and Penelope Bennett; 168 pages.

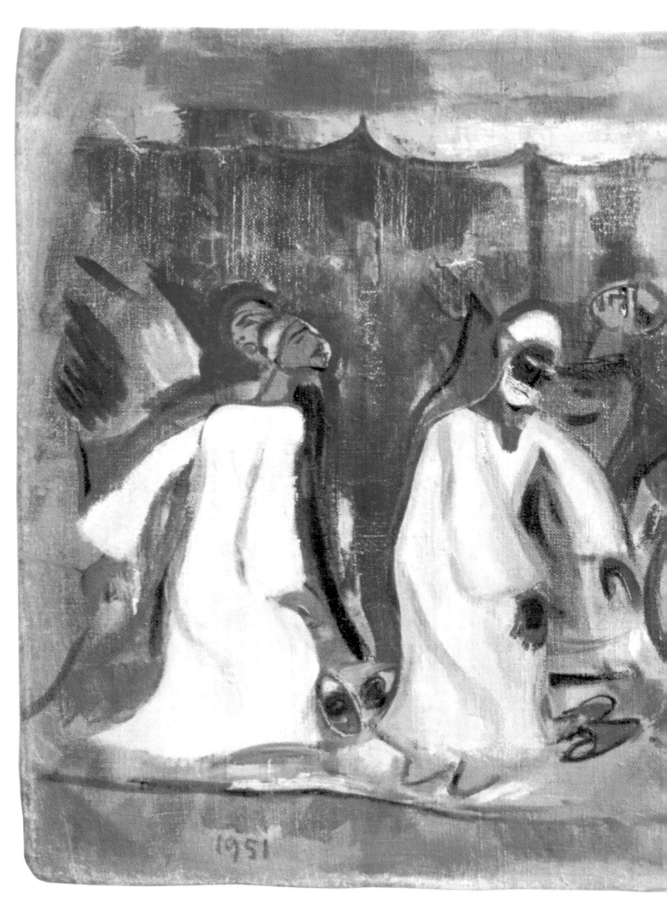

Zikr, oil on canvas, 43x66, 1951

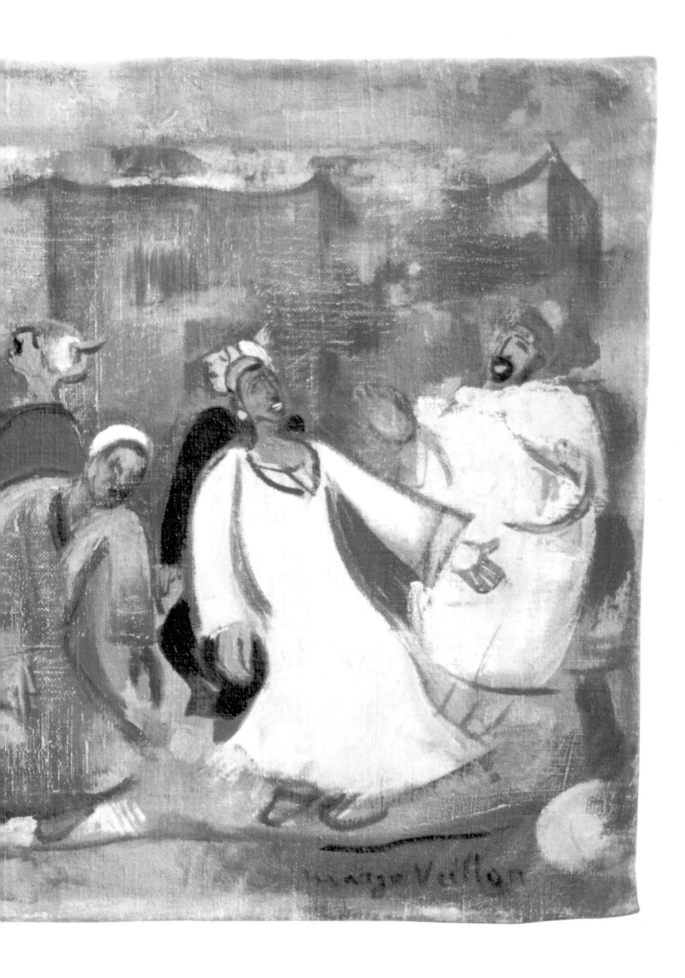

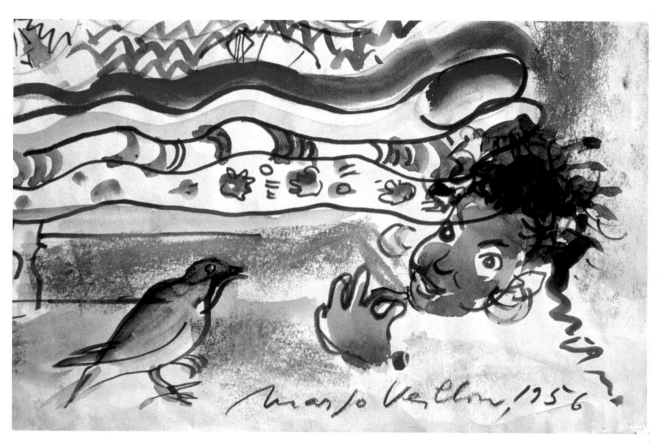

Festive room in Nubia, detail